For Jack Craddock and in memory of Leila Gorchev

IN PLANE VIEW / Abstractions of Flight

>>

Photographs by **Carolyn Russo**

>>

Foreword by Patty Wagstaff
Introduction and essays by Anne Collins Goodyear
Captions by David Romanowski

To Keune & Kitty Wolcott,
Very Best Wishes
to you both.

Truly,

Carolyn Russo

Smithsonian
National Air and Space Museum

pH powerHouse Books Brooklyn, NY

FOREWORD
>>

Flying is an art.

I see the sky as a medium, a painter's canvas. You work to develop your skill and precision and then you can take it to another level. You get to a point where you have total mastery of the airplane, working as one cohesive unit and making it a very natural experience. You're an artist who can take the plane across the sky in a way that looks and feels just beautiful—slowing it down, speeding it up, carrying out really intricate, unusual maneuvers, creating your own statement while mechanically meshed with the machine in its every tumbling attitude. Your skills get so refined that you can almost stop the plane on a heading and put it exactly where you want to put it every time. That's when it's art. Even the laws of gravity can be defied—at least temporarily—and the only limits to the perfect flight are of imagination.

Unfortunately for aerobatic pilots, the sky is a temporary surface. Once a great sequence is finished, it's gone forever, like a perfect dance, sunset, or bloom. Even the best cameras can record just a two-dimensional hint of what was accomplished during a routine—and sometimes you wonder whether a performance can fully be appreciated beyond the canopy. I'm sure I have the best seat at every show even if I am, technically, at work.

Modern flying machines are built to withstand years of service. You don't even have to like flying to enjoy them. Every day when I look in the hangar at my airplane, I see this beautiful piece of symmetry. I've been that way since I was a little girl, just looking at planes and trying to get close to them. I loved them before I flew them and will love them after I can't fly anymore. You see that reaction every day at the National Air and Space Museum. With its remarkable collection, the museum's unprecedented popularity is no surprise to me.

Even before I donated my hand-built, championship Extra 260 to Air and Space in 1994, I've felt that any airplane I fly should look

like a museum piece. If it isn't beautiful, I don't want to fly it. I once had a plane built and it was really unattractive. I refused to fly it. Then I sold it. My feeling was if I don't think the plane is beautiful, I don't want to be seen with it. I don't care how well it flies. I know that sounds crazy but the form of the plane has to match the function to create beauty. It has to be a total combination of art and science, form and engineering—everything that takes me to the absolute freedom I find in the sky.

The photographs in this book are also about finding a certain freedom. Carolyn Russo has managed to take the overall beauty I see in airplanes—and spacecraft and other artifacts of flight—and frame their art in pieces rather than as whole subjects. It's an abstract approach that gives new life even to the most familiar icon. By exploring colors, angles, textures, and shadows, Carolyn shows that, as with the perfect flight, the only limits are of imagination. And the depth of her work is almost three-dimensional.

Carolyn's photos have brought my focus to a new level. I finally see the smaller details that make up the whole. Now, when I look at my plane's exhaust stacks, I appreciate their unique form and, as a result, their unique role in my performances. You won't need to know an aileron from a trim tab to enjoy these images. Just summon the same curiosity that pauses to consider a fine contrail across a clear winter sky.

In many ways, Carolyn's work process is the opposite of mine. She takes permanent surfaces and asks the viewer to supply the intended motion. But we both are seeking to capture the unique energy of flight. It's our shared destination.

These photographs are all about finding the art within the National Air and Space Museum collection. You will be transported to a whole different place.

Patty Wagstaff
Air show performer and U.S. National Aerobatic Champion 1991–1993

TABLE OF CONTENTS
>>

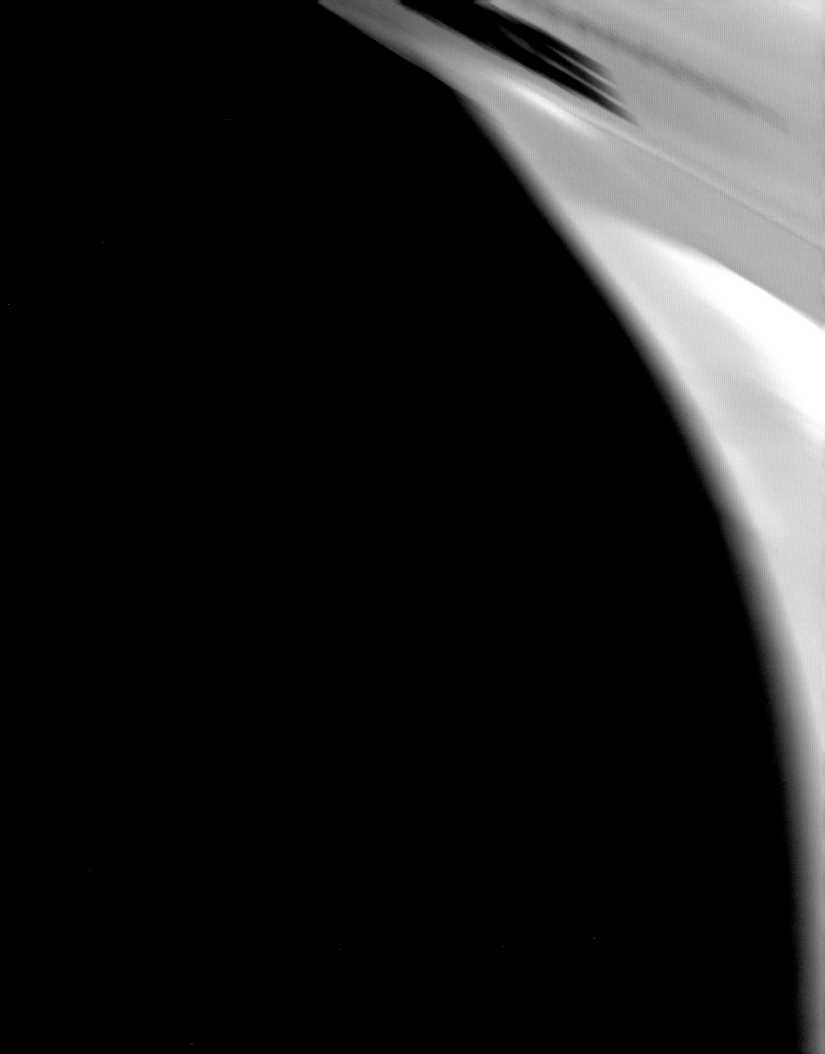

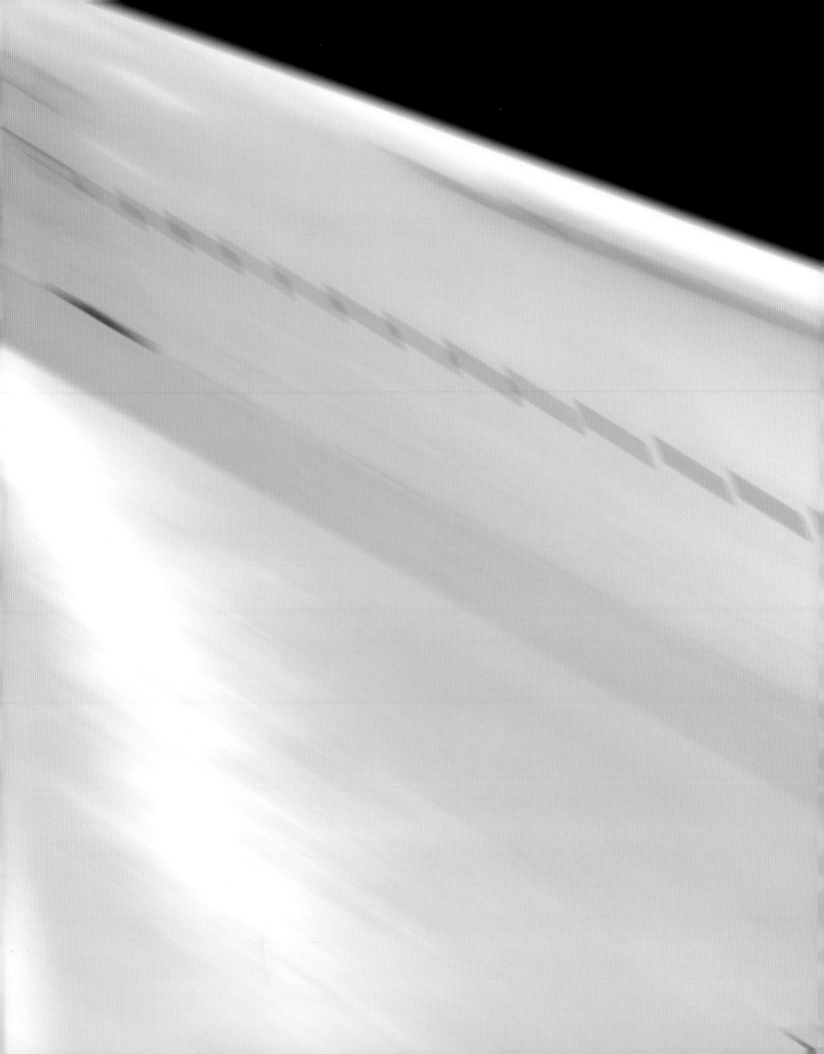

Wittman Chief Oshkosh /
Buster

P.8-9. Concorde, Fuselage and Wing

"I have often said that the lure of flying is the lure of beauty, and I need no other flight to convince me that the reason flyers fly, whether they know it or not, is the aesthetic appeal of flying."

—*Amelia Earhart,*
First female pilot to complete a solo flight across the Atlantic

from *Last Flight*, 1937

>>*Tail*

The deep red color and rounded curves of the tail suggest a Valentine heart—or perhaps, with the line marking the edge of the horizontal stabilizer, a broken heart.

The tiny, barn-red, homemade airplane first named *Chief Oshkosh* and later *Buster* was built for racing competition by Steve Wittman, who began entering it in midget category races in 1931. By the time Wittman retired the airplane more than two decades later, it had established perhaps the longest and most successful career in air racing history.

Not that it was all smooth flying. The midget racer suffered wing flutter problems early on, survived two landing accidents, and underwent a succession of engine changes, wing alterations, and other modifications. But for most of its career, it placed consistently high in major races and won a good many of them. In 1937 it set a world's record for its class over a 100-kilometer course with a speed of 238 miles per hour.

The *Chief* competed annually in national and international competitions from 1931 to 1938, when a crash landing put it out of commission. Then World War II intervened, and air racing ceased. Wittman's airplane reappeared in 1947, revamped and renamed, and resumed its winning ways with other pilots at the controls. Its final race was in Dansville, New York, on July 4, 1954. It placed third—not bad for a 23-year-old airplane.

INTRODUCTION
>>

"The only true voyage of discovery...[is] not to visit strange lands but...
to see the universe through the eyes of another...this we can do with [an
artist]; with [artists] we do really fly from star to star."

—Marcel Proust, from "The Captive"

To speak of the airplane's relationship to modern and contemporary art
may at first sound surprising, or possibly forced. But, in fact, even a quick
overview of art from 1903 to the present reveals the extraordinary
influence of the invention of mechanical flight and space flight on the
development of art over the course of the past century. The airplane and
its descendants introduced new modes of perception from increased
speed, to aerial views, to changing experiences of scale, and even of
weight—which no longer keep one Earth-bound. Since the early
twentieth century, when the airplane first made its public debut, artists
have responded to it, often using the bold rhetoric of modern abstraction.
Among the best-known painters, sculptors, and printmakers to do this are
Henri Rousseau, Pablo Picasso, Kazimir Malevich, Fernand Léger, Robert
Delaunay, Charles Sheeler, Arshile Gorky, Georgia O'Keefe, Robert
Rauschenberg, Nancy Graves, Richard Serra, and Yvonne Jacquette.

 Carolyn Russo's complex photographic abstractions build on
this rich heritage with their unique combination of visual sophistication,
humor, and respect. Through the medium of photography, Russo exposes
the bold colors, textures, shapes, and patterns that characterize diverse
flying machines, but which often escape our attention. As a staff
photographer at the Smithsonian Institution's National Air and Space
Museum in Washington, D.C., Russo has unique access to the iconic
aircraft she pictures. The images brought together here reflect Russo's
intimate contact with her subjects—which at times seem almost human—
garnered during daylight hours amid large crowds and in the darkness of
the museum after hours, when solitude permits personal reflections.
Through her non-traditional views of some of history's most important
aircraft, such as the 1903 Wright Flyer, Chuck Yeager's Bell X-1
Glamorous Glennis, Amelia Earhart's Lockheed Vega, and the Apollo 11
Command Module *Columbia* that participated in the world's first lunar
mission, Russo demonstrates not only the powerful aesthetic appeal of
these vehicles, but also provides refreshing insight into the unique
qualities that set each one apart.

 The rusty red roughness of the Command Module *Columbia*
simultaneously evokes the lunar surface and resonates with Michael
Collins' observation that from the Moon it is the Earth's deserts that
remain visible, resembling "a smear of rust color." The radiating pattern
on the heat shield of the Mercury *Friendship 7* suggests the "fireflies" John
Glenn reported seeing from space as he flew the vehicle. The flag on the
side of the Gemini IV space capsule not only functions as an arresting
image, but bespeaks the patriotic spirit that propelled space flight forward.
In Russo's hands the Wittman *Buster* becomes a vibrant red heart—"a big,
red Valentine's heart with an arrow through it," according to Russo—
capturing a spirit of fun and adventure as well as a passion for flight.
Elsewhere, the texture and curvature of the step into Wiley Post's
Lockheed Vega *Winnie Mae* resemble a cosmic ear of corn, suggesting both
Russo's own humor and the degree to which one's vantage point can
transform the appearance of things—one of the lessons of flight itself.

Russo's photographs identify aesthetic allure in unexpected sources. Describing her response to the Homing Overlay Experiment Test Vehicle, Russo observes, "I was just trying to turn it into something beautiful." In another instance, Russo isolates markings on the fuselage of a German Focke-Wulf Ta 152 H World War II fighter to create a composition that could be a study in painterly abstraction.

Russo selectively employs digital enhancement as a tool. Creating a picture of the North American X-15, Russo replaces the gray-black tonalities of the grooves etched into the plane's exhaust cone with a vibrant blue. In so doing, Russo creates the impression of bright light, speed, and an explosion of energy, consistent with the X-15's capabilities. The first plane to enter the hypersonic realm, many times greater than the speed of sound, the X-15, capable of flying outside the Earth's atmosphere, is still the fastest plane on record. Similar aesthetic considerations inform Russo's exaggeration of contrast and her introduction of blue in response to the Lockheed SR-71A Blackbird, known for its rapid movement and elusiveness. Russo not only plays with color to distill the character of particular planes, but also uses digital techniques to create a pattern of receding propellers in her depiction of the propeller of the Focke-Wulf Fw 190 F, accentuating the swirling geometry of the blades that first attracted her.

One of Russo's accomplishments is to take her own measure against aircraft, creating intriguing associations between these machines and the human beings. An experienced photographer of faces, Russo elicits "portraits" of planes, bringing out different characteristics. Like people, some become funny, others elegant, still others darker and more serious. "I used to know that guy," jokes Don Lopez, a former Curtiss P-40 pilot and Deputy Director of the Smithsonian's National Air and Space Museum, about Carolyn Russo's photograph of the McDonnell F-4S Phantom II. The image transforms the airplane's jet engine exhaust into an engaging creature—part robot, part extraterrestrial—with its huge eyes, long nose, and horizontal mouth. Elsewhere, the seductiveness of advanced technology is correlated more directly with the body, evoking its curves, its veins, and even its virility. The continuum of life requires death, and accordingly, one connection is more sobering. Russo's depiction of the Boeing B-29 Superfortress *Enola Gay*, which released the first atomic bomb to be used in warfare, seems to evoke skeletal remains.

Broken up into five categories—Speed, Bursts, Movement; Flora, Fauna, Anthropomorphism; Propellers; Graphics; and Textures / Skin—which occasionally overlap, Russo's photographs reveal new layers of meaning from the whimsical to the profound through their unconventional representations of well-known air and spacecraft. In combination with the words of pilots, poets, and other artists, whose words resonate with these images, Russo's work evokes the beauty, wonder, excitement, and even danger associated with flight. Detailed descriptions of each aircraft, provided by David Romanowski, document their historical accomplishments and contributions. With her playful juxtapositions, her discerning eye, and a masterful command of her medium, Carolyn Russo transforms technology into art, providing new landscapes ripe for exploration.

Anne Collins Goodyear
Assistant Curator of Prints and Drawings
National Portrait Gallery, Smithsonian Institution

SPEED, BURSTS, MOVEMENT
>>

Bell X-1
Glamorous Glennis

"The highest art form of all is a human being in control of himself and his airplane in flight, urging the spirit of a machine to match his own."

—*Richard Bach*
Pilot and author

Picturing a group of record-breaking aircraft, Carolyn Russo uses color, line, and pattern to accentuate power and speed. Here Chuck Yeager's Bell X-1 *Glamorous Glennis* appears from below. This view of the bright orange belly of the plane that first flew faster than sound in 1947 mimics the perspective of those over whom it first flew, emphasizing its hurtling motion.

The Lockheed SR-71A Blackbird seems to zoom forward into space in one photograph. Another picture, with enhanced color, depicts the neon-like rings of the spy plane's afterburner, which increases the jet's thrust. A similar effect can be glimpsed in Russo's depiction of the North American X-15, which is represented through its exhaust cone, the striations of which suggest the burst of energy the hypersonic plane requires to reach the edge of the Earth's atmosphere.

Elsewhere, these suggestive abstract photographs capture the pure aesthetic achievements of the engineering of these highly sophisticated vehicles. The tail of the Hiller XH-44 Hiller-Copter tapers to a fine point, suggesting the architecture of a soaring modern building or the finesse of a pencil point. The CFM International CFM56-2 engine resembles a work of modern art, with its abstract spiral inviting motion. Russo's depiction of the Homing Overlay Experiment Test Vehicle's extended ribs transforms a defensive weapon into an object of beauty, the fan-like armature of which evokes not only the feathers of a peacock, but also the protective spines of a porcupine.

from *A Gift of Wings*, 1974

>>*Fuselage (upside down)*
The X-1's bright orange color gave the plane optimum visibility to tracking cameras and chase planes. The long and narrow raised bump in the center of the fuselage is the main skid used for emergency landings.

Piloted by U.S. Air Force Capt. Charles E. "Chuck" Yeager, the Bell X-1 named *Glamorous Glennis* (after Yeager's first wife) pierced the mythical sound barrier on October 14, 1947. It reached Mach 1.06, just a bit faster than the speed of sound, something no aircraft had ever done before.

Yeager wasn't the only pilot to fly the X-1, and *Glamorous Glennis* wasn't the only X-1 to fly. It was the first of three XS-1s, as the aircraft were first known. The XS-1 program to develop transonic and supersonic piloted aircraft was initiated by the National Advisory Committee for Aeronautics (the NACA, forerunner of NASA) and the U.S. Army Air Forces (later the U.S. Air Force). Bell Aircraft of Buffalo, New York, built the rocket-powered test vehicles.

The X-1's skin was made of high-strength aluminum and its lines were patterned after the shape of a .50 caliber machine gun bullet. A Boeing B-29 or B-50 Superfortress carried aloft and air-launched all but one X-1, which took off from the ground. *Glamorous Glennis* completed 59 test flights for the Air Force, flying as high as 71,900 feet and as fast as Mach 1.45, more than 950 miles per hour, soundly debunking the notion of an aerodynamic barrier to supersonic flight.

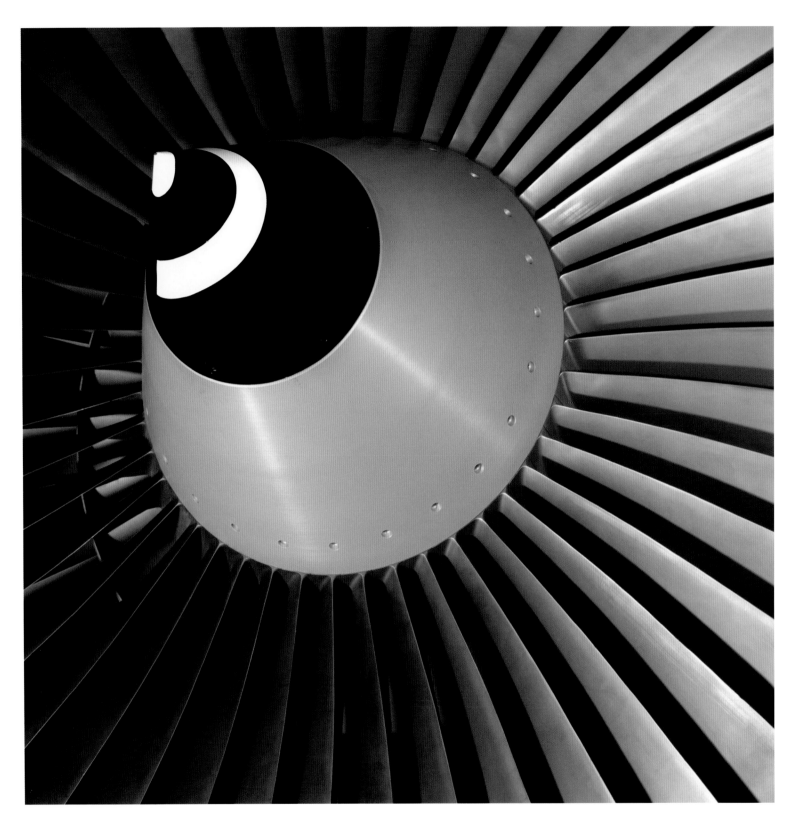

CFM International
CFM56-2 Engine

>> Turbofan Blades

The turbofan blades increase the flow of air around the core of the primary jet turbine. For every pound of air entering the jet engine, the turbofan draws six pounds of air past the engine, providing much extra thrust. The bypassed air mixes with and cools the jet exhaust, reducing exhaust noise.

The jet age brought the piercing whine of jet engines to airports and their surroundings across the nation. While the speed and economy of jet travel were welcome changes, increased noise levels were not. Engineers began working on new engine designs that were not only quieter but also more powerful and fuel efficient.

The turbojet engines that powered those early jetliners derived all their thrust from their engine exhaust. New turbofan engines introduced an additional mechanism: turbine blades at the front of the engine move most of the air past the engine core like a big fan, which creates bypass air. The bypass air combined with the jet engine exhaust increases the thrust. This design consumes less fuel, produces less exhaust, and is much quieter as well. High-bypass and low-bypass turbofans differ in the amount of air their fan blades move, with high-bypass turbofans providing even greater efficiency.

The CFM56-2 high-bypass turbofan was introduced by the joint U.S./French company CFM International in the early 1980s. It replaced turbojet engines on some older aircraft, such as the Douglas DC-8 (one of the first U.S. jetliners), and was installed on many newer models, including the Boeing 737 and Airbus A320 and A340. CFM56-2s were also installed on Boeing KC-135Rs and other military transports.

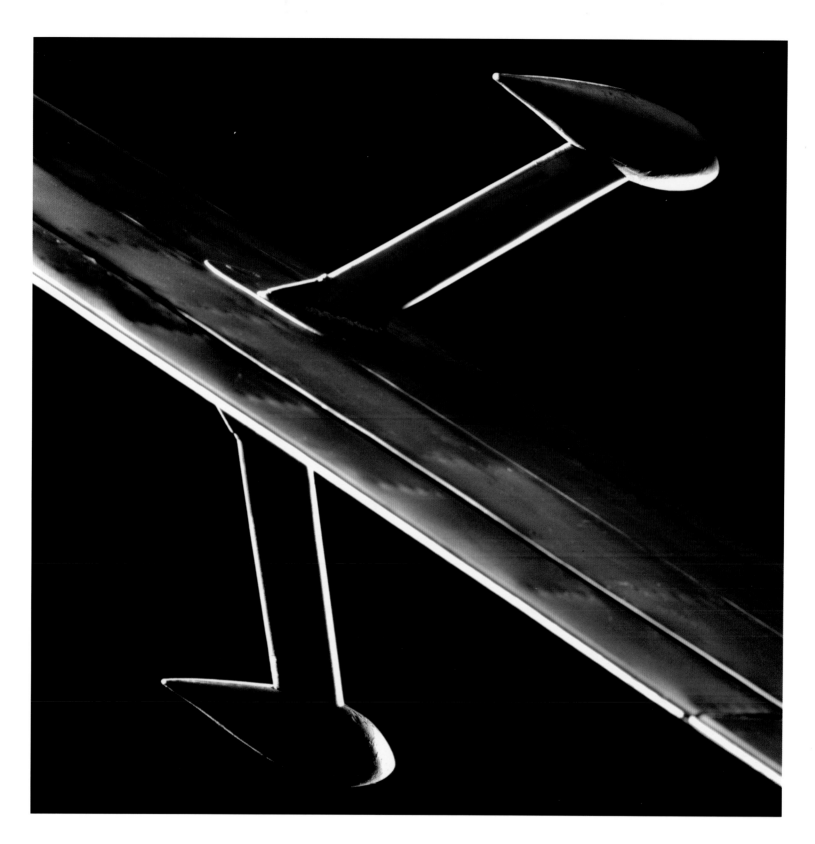

Lockheed P-38J Lightning

>>Counterweights

The P-38 prototype experienced a flutter in the tail section during high-speed dives. Counterweights were mounted above and below the stabilizer in an attempt to reduce the problem. Although not completely successful, the counterweights remained in the final design.

With its twin-boom tail and twin-engine configuration, the P-38 Lightning was one of the most distinctive, effective, and advanced fighters of World War II. Lightnings entered combat in 1942 and fought throughout the war in Europe, the Mediterranean, North Africa, and the Pacific from the Solomon Islands to the Aleutians.

Created by a team led by legendary Lockheed designer Clarence "Kelly" Johnson, the Lightning served many roles: photo reconnaissance, interceptor, ground attack (its dual engines helped reduce aircraft losses), and bomber escort. It could carry cannons, machine guns, rockets, or bombs.

The P-38 had a lengthy shakedown period, during which engineers worked to resolve the unforeseen problems of an innovative design, such as loss of control during high-speed dives because of shock waves forming on the wings. But by mid-1944, the P-38 finally reached its envisioned potential.

With their superior range and combat performance at mid-level altitudes, P-38s were most effective in the Pacific.

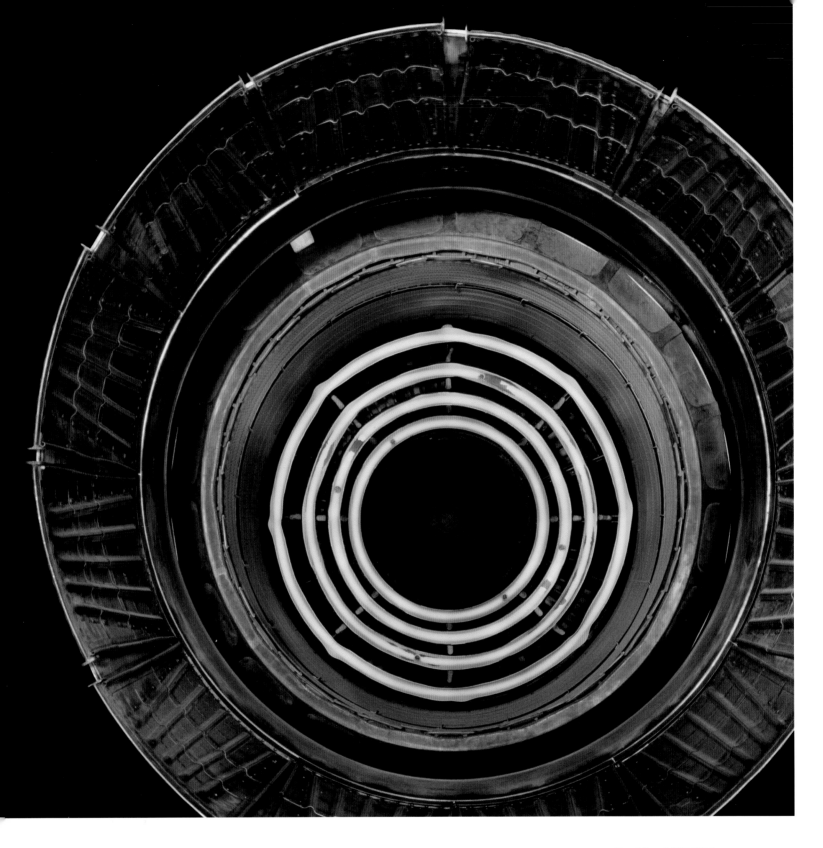

Lockheed SR-71A
Blackbird

"We are coming into a new era of flight, an era in which all past conception of time and distance is changing and changing at a very, very rapid rate."

—*Allan Lockheed*
Founder of Lockheed Aircraft

from the film outtake of *We Saw it Happen*, 1953

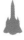

>>*Exhaust Nozzle*

The four bright afterburner rings dispense jet fuel into the hot engine exhaust. The fuel ignites, providing a boost in thrust. The afterburner was used almost constantly, except during air-to-air fueling.

Powerful, and astonishingly fast, the SR-71 reconnaissance plane has an almost futuristic appearance that belies its age; it was conceived during the Cold War tensions of the mid-1950s and introduced in the early 1960s. No jet-powered aircraft has ever gone higher or faster.

The Blackbird evolved from an aircraft designed for the CIA to supersede its subsonic U-2 spy planes. It had to fly fast enough and high enough to elude Soviet interceptors and surface-to-air missiles. Lockheed's top-secret "Skunk Works" responded with a stealthy, supersonic aircraft with custom-designed engines and titanium alloy skin that could handle the shockwaves and 800 °F heat generated by speeds up to Mach 3.3. Its specially formulated black paint absorbed radar signals, radiated frictional heat, and provided camouflage against the dark high-altitude sky. Its two crewmen wore astronaut-like pressure suits to protect them at altitudes of up to 85,000 feet.

Although satellites were replacing reconnaissance aircraft, SR-71s performed vital missions until 1990, when the Air Force retired the Blackbird. On its final flight, the National Air and Space Museum's SR-71 set a cross-country speed record, flying from Los Angeles to Washington, D.C., in 1 hour, 4 minutes, and 20 seconds, averaging 2,124 miles per hour.

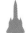 *Lockheed SR-71A*
Blackbird

>> Twin Tail

Side lighting illuminates the rudder, stabilizer, and round engine exhaust. The small circle at the rear point of the fuselage is a tail navigation light.

>>*Engine Air Inlet and Wing*

The long cone that covers the driveshaft is part of a complex air inlet system needed to prevent shock waves from moving into the Pratt & Whitney J-58 engine. The dull black titanium skin dissipates heat and absorbs radar waves.

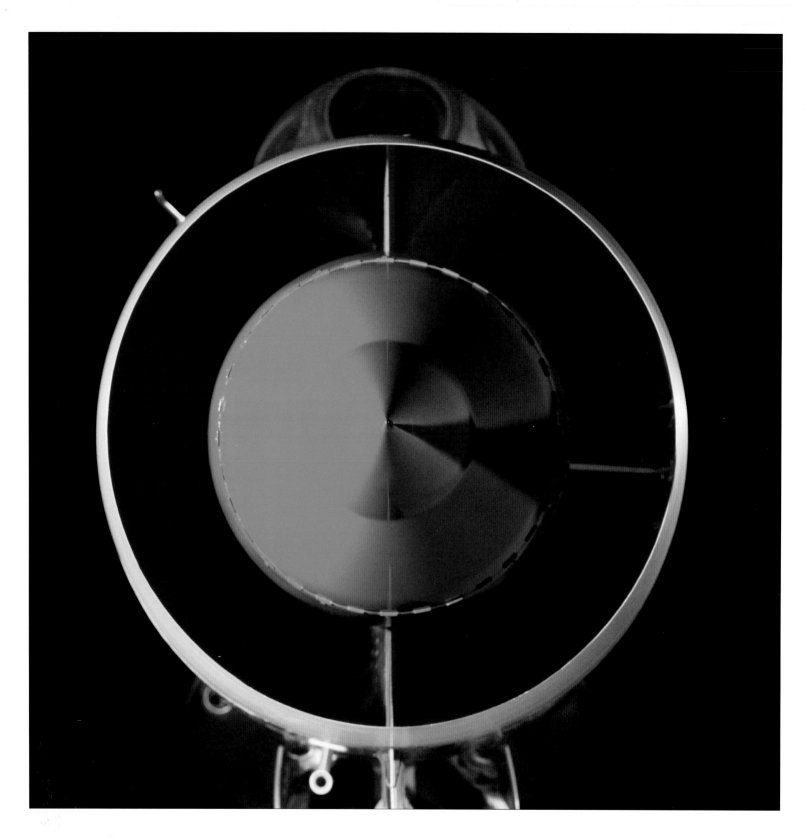

Mikoyan-Gurevich
MiG-21F-13 "Fishbed C"

>>Radar Nose Cone

The nose cone houses a radar antenna and
is part of the air inlet system for the turbojet
engine.

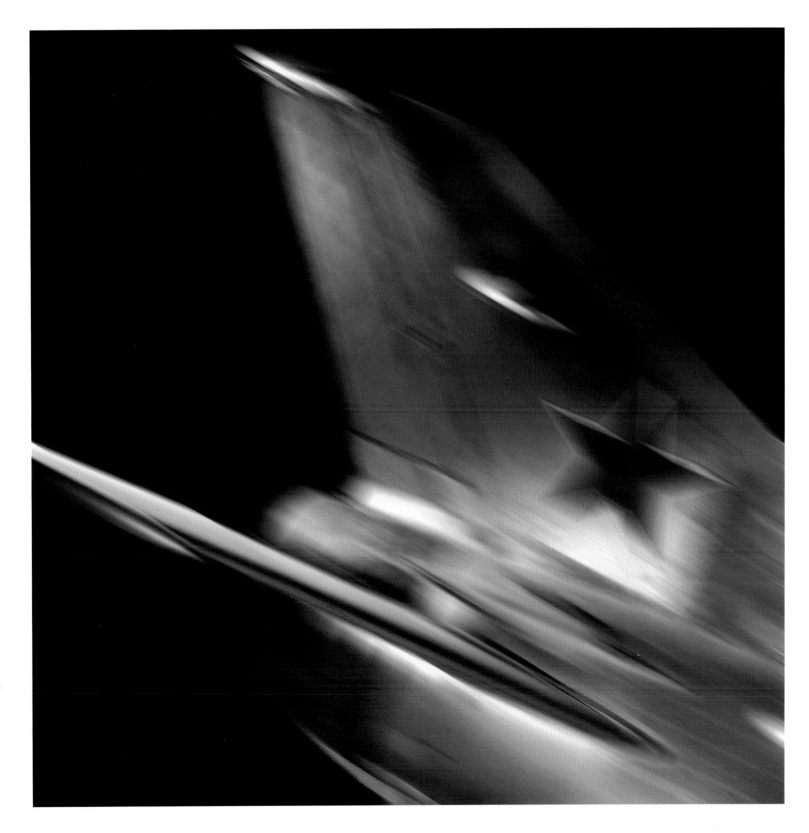

>>Tail Section

This tail view shows the rudder, horizontal stabilizer, and aft end of the fuselage. The red star is the marking for Soviet aircraft.

The first truly modern third-generation Soviet jet fighter, the MiG-21 entered service in 1960. Nearly half a century later, the air forces of many nations still fly newer versions of the aircraft.

Characterized by a very thin "tailed delta" wing (a triangular wing with traditional horizontal and vertical stabilizers), the first version, the MiG-21F-13, was fast and performed well at medium altitude. Initially, it was equipped with two K-13 air-to-air, heat-seeking missiles, better known by their NATO code name Atoll. The Atoll was a direct Soviet copy of the U.S.-designed Sidewinder missile, one of which had been fired into a Chinese aircraft, failed to explode, and was recovered intact. Although initially a "clear-air" interceptor, the addition of radar, more powerful engines, a variety of armament, and other improvements enabled the MiG-21 to perform multiple roles, including ground attack.

The Soviet Union exported MiG-21s as a way of establishing international relationships, and nations such as India and China have produced versions of their own. Thus, MiG-21s have turned up in combat around the globe, including the Arab-Israeli conflicts of 1967, 1973, and later; the 1971 altercation between India and Pakistan; and the Vietnam War.

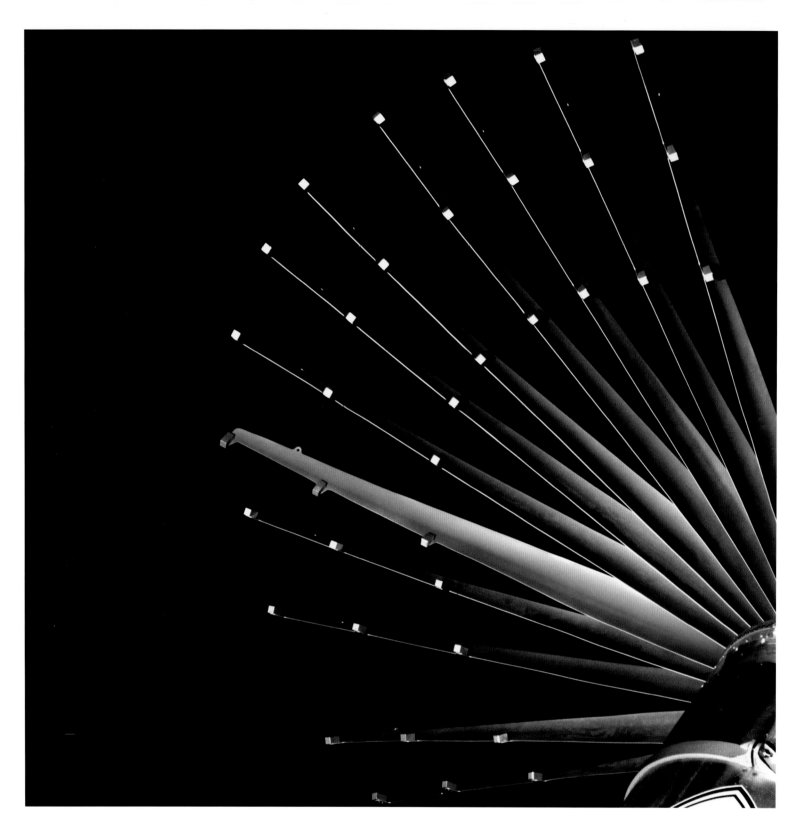

Homing Overlay Experiment Test Vehicle

>>Extended Rib

The HOE was designed to destroy an incoming ballistic missile by colliding with it. The ribs unfolded in space to broaden the HOE's surface area. The chances of hitting the target were increased with the deployed ribs.

Since the early days of the Cold War, the U.S. military has experimented with many means of defending the nation against an attack by long-range ballistic missiles. The earliest systems developed by the military used antiballistic missiles that would destroy missiles en route above the atmosphere by detonating nuclear or conventional warheads near them. This method had numerous drawbacks, not the least of which was exploding nuclear

warheads over friendly territory.

In the early 1980s, the U.S. Army began experimenting with "hit-to-kill" vehicles, which were designed to destroy a missile by colliding with it rather than blowing it up. The first test of this concept was the Homing Overlay Experiment (HOE). In a series of four tests conducted in 1983–84, a Minuteman missile with a dummy warhead was launched from Vandenburg

Air Force Base in California toward the Pacific island of Kwajalein, 4,000 miles away. The HOE was launched from Kwajalein Missile Range to intercept the dummy warhead in space.

The first three tests failed because of problems with tracking or guidance systems on the HOE vehicles. The fourth test was successful. The technology tested by the HOE formed the basis for hit-to-kill antiballistic missile systems in use today.

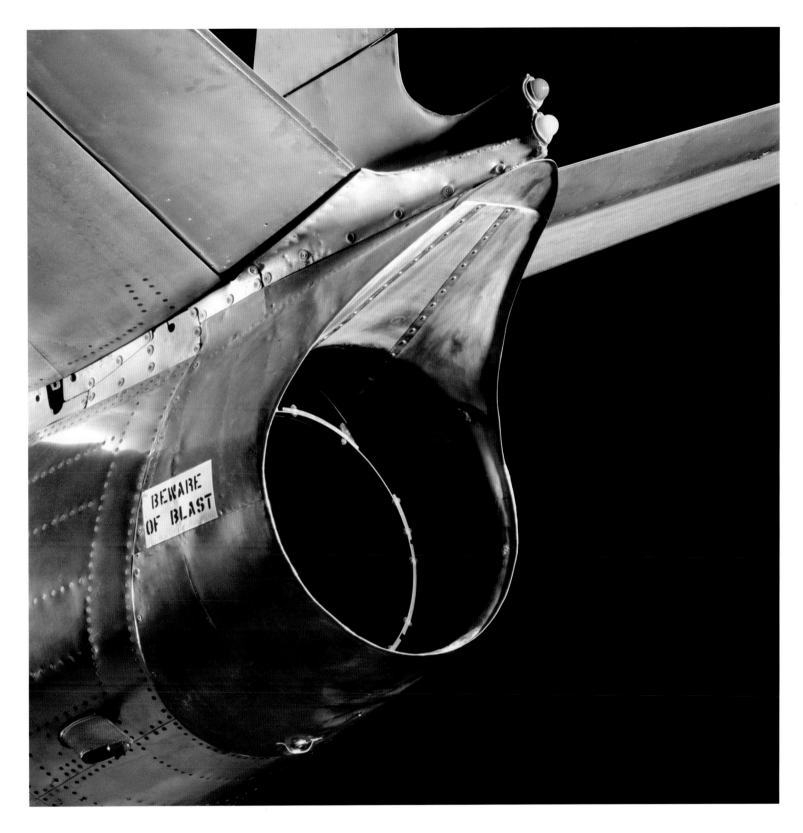

North American F-86A Sabre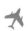

>>*Engine Exhaust*

A view of the rear fuselage shows the engine exhaust, the lower portion of the rudder, both horizontal stabilizers, and the navigation lights. The hot high-speed "blast" from the engine was a hazard to ground crewmen.

Jet fighters and bombers first appeared during World War II, but not until the Korean War did jets face off against one another. On December 17, 1950, the first known combat between sweptwing fighters occurred, and it proved prophetic.

The F-86 concept emerged in 1944, when the Army Air Forces ordered three test versions of a jet fighter being designed for the Navy. The Army wanted a fighter that could fly up to 600 miles per hour,

but a year later the prototype XP-86 was still far short of that goal. However, captured aeronautical research data that Germany had used to develop its own jets prompted designers to reshape the XP-86, changing the straight wing to a sweptback wing, which greatly improved the aircraft's performance.

The XP-86 finally flew in 1947, and a year later an F-86A set a world speed record of 671 miles per hour. Armed

initially with six nose-mounted .50 caliber machine guns, the F-86 progressed through several more heavily armed versions.

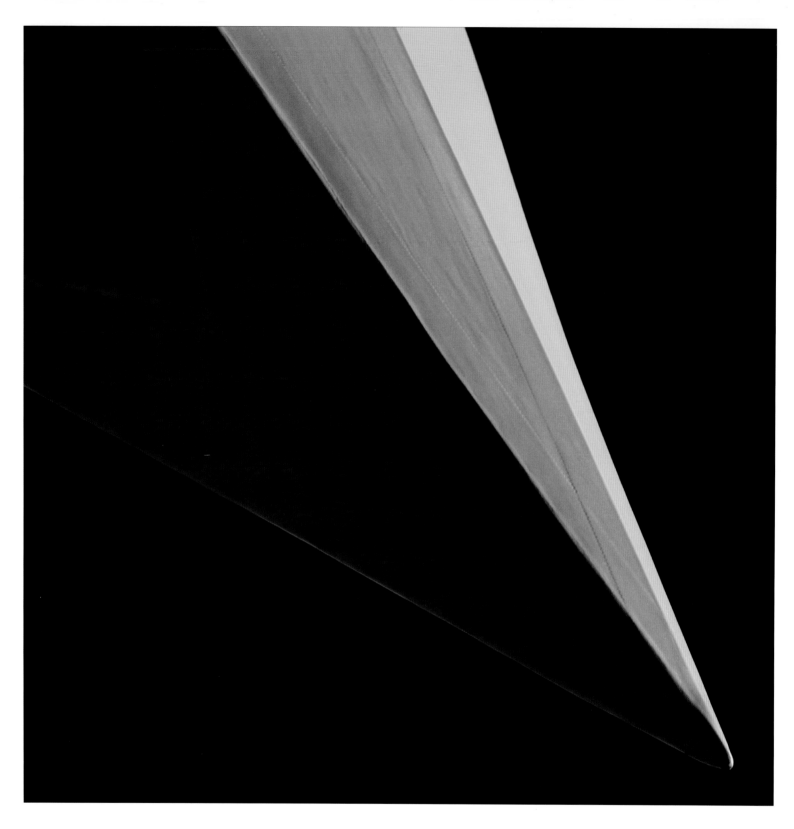

Hiller XH-44
Hiller-Copter

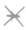

>>*Tail*

Helicopters usually have a small rotor at the tail to counteract the torque produced by the main rotor. The XH-44 has two separate sets of blades rotating in opposite directions, so it doesn't need a tail rotor. The tail simply tapers to a point.

In 1944, Igor Sikorsky dominated the fledgling U.S. helicopter industry with his single main rotor designs. Stanley Hiller Jr. decided to create an alternative. He designed, built, and test flew the first helicopter in the country to fly with two counter-rotating coaxial blades. His XH-44 was also the first to successfully fly with all-metal blades and a rigid (hingeless) rotor. At the time, Hiller was only 19 years old.

The coaxial rotor concept had already been proven in Europe. It eliminated the need for a tail rotor to counteract torque, but it introduced other problems related to control. The testing phase was bumpy. Hiller's first engine run-up sucked the skylights from the ceiling of his workshop. He equipped the craft with floats and hauled it out to the family swimming pool for further testing. The copter tipped over during its first tethered test flight, which

took place on the family driveway.

Undaunted, Hiller kept refining the XH-44, and it did fly successfully. But the boom in personal flying, which many predicted would take place after World War II, fizzled—and along with it, the market for light aircraft, whether fixed- or rotary-wing. Hiller's aircraft company finally prospered by producing more conventional helicopter designs for the commercial and business market.

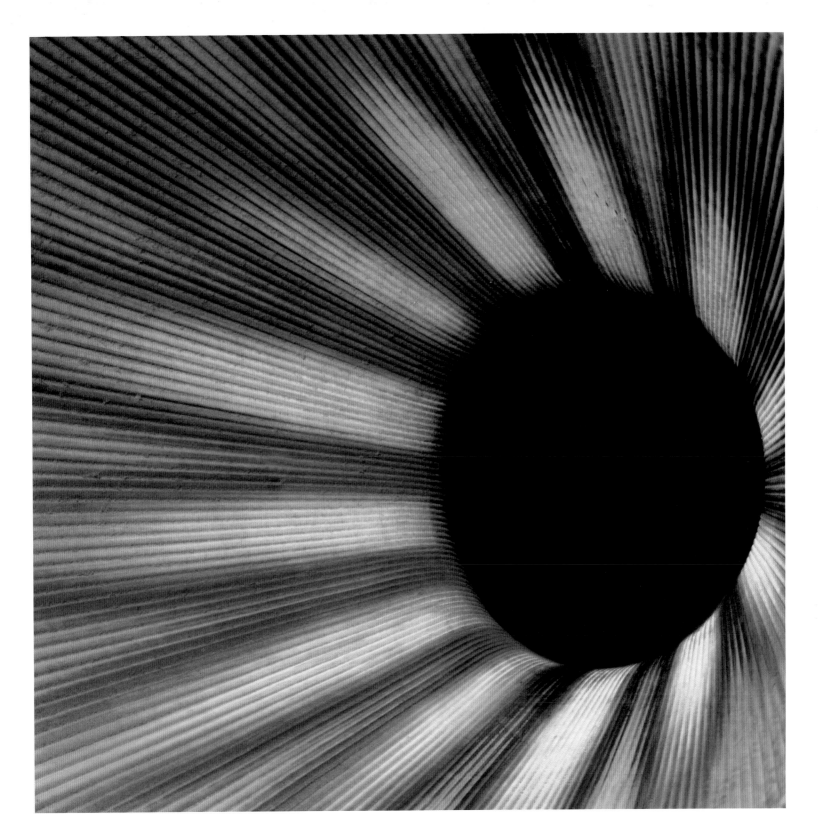

North American X-15

The three X-15 research vehicles flew higher and faster than any other aircraft. They reached the transitional realm between the atmosphere and space, as high as 67 miles—5 miles beyond what is considered the boundary of space. They entered a whole new speed regime, beyond supersonic and into *hyper*sonic—Mach 5 (five times faster than sound) or greater. The X-15s remain the fastest aircraft ever flown. One reached Mach 6.72—4,534 miles per hour.

To operate at such extreme speeds and altitudes, an X-15 had to be part aircraft and part spacecraft. It was made of titanium and covered with a nickel alloy called Inconel X, which could withstand frictional heating of 1,200 °F. The X-15's black color helped dissipate the heat. Thruster rockets in the nose and wings enabled the pilot to control the craft at altitudes where there wasn't enough air to use control surfaces. The pilot, like an astronaut, wore a full pressure suit.

The first X-15 flew in 1959. Carried aloft and released by a Boeing B-52 bomber, the rocket-powered craft would blast upward to the fringes of space, then glide to a landing on wheels and skids. The concept of using an air-launched, piloted vehicle to reach space reemerged in 2004 with SpaceShipOne, which broke the X-15 altitude record by 3 miles.

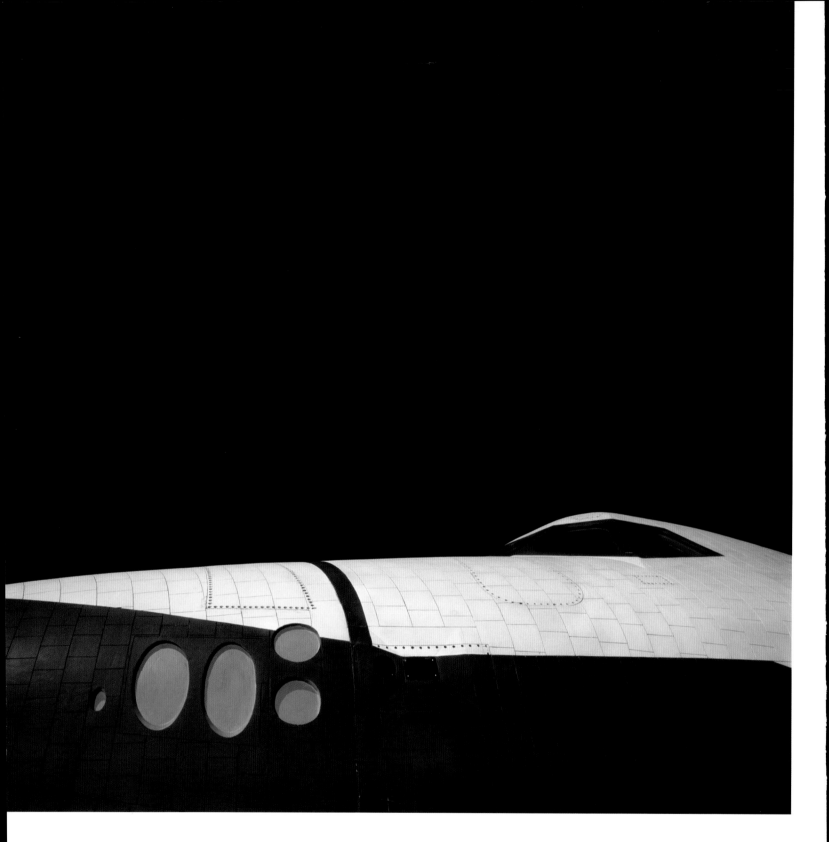

Space Shuttle Enterprise

"Man must rise above the Earth—to the top of the atmosphere and beyond—for only thus will he fully understand the world in which he lives."

—Socrates

from *Slipping the Surly Bonds*, 1998

>>Thrusters

This side view of the shuttle shows the location of some of the various gas thrusters used to maneuver the spacecraft in orbit.

With its first test flight in 1977, *Enterprise* heralded a new era of human spaceflight. The Space Shuttle was the first spacecraft that could be flown repeatedly. From 1981 through 2006, 116 shuttle launches took place. Shuttle orbiters carried as many as eight crew members and transported large payloads into space, including military and commercial satellites, the Hubble Space Telescope, and components for the International Space Station.

Enterprise never flew in space. It lacked propulsion systems and was clad only in simulated versions of the thermal tiles that would protect other shuttles during reentry. As the shuttle prototype, *Enterprise* was used for testing systems and flight performance in the atmosphere during approach and landing tests at NASA's Dryden Flight Research Center in California. A Boeing 747 jetliner carried *Enterprise* aloft and released it, then the

shuttle glided to a landing. The spacecraft was also used for launch vibration tests and fit checks at other NASA centers.

Long after it was retired from service and became a Smithsonian museum piece, *Enterprise* played an important role in the shuttle program. NASA engineers borrowed some of its wing leading edge panels and its main landing gear doors for testing during their investigation of the Space Shuttle *Columbia* accident.

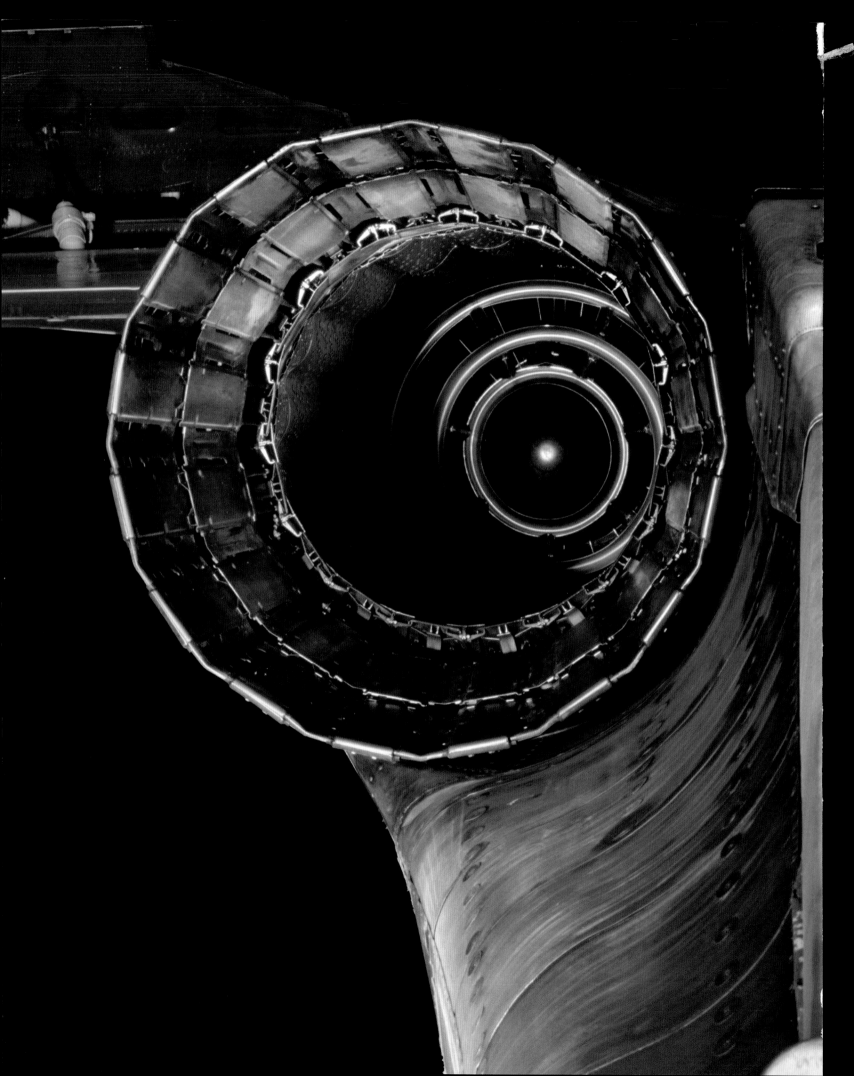

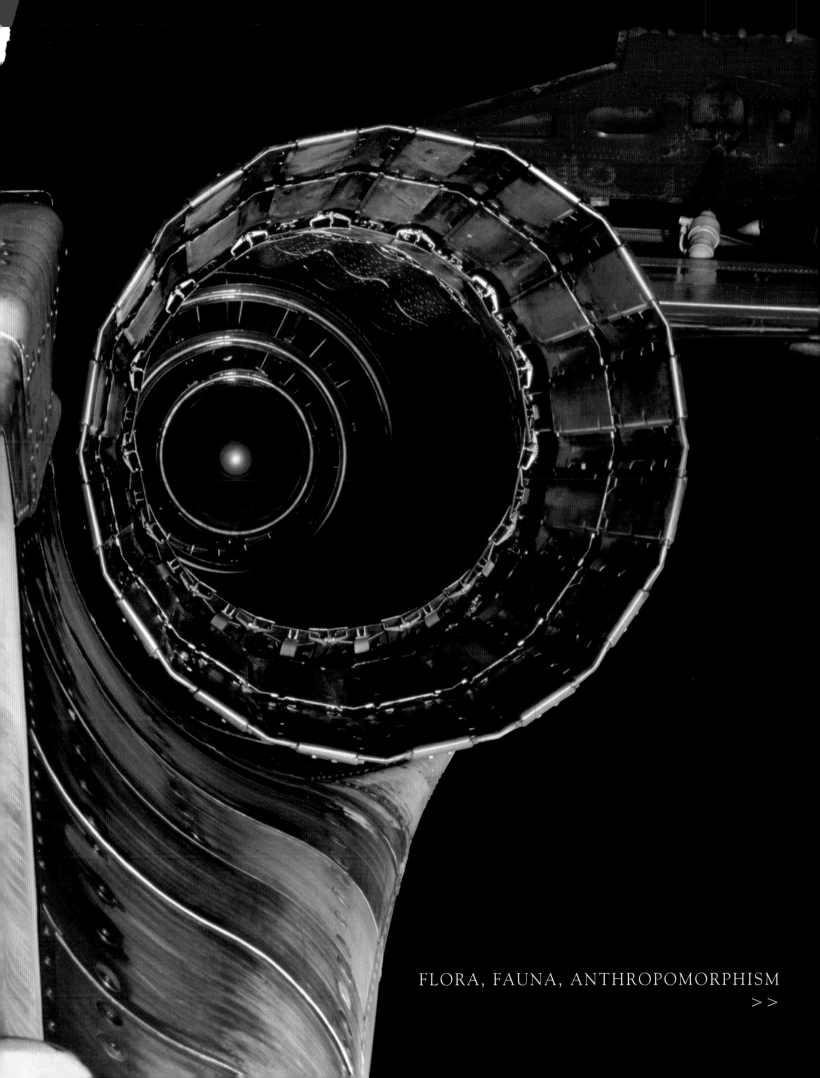

FLORA, FAUNA, ANTHROPOMORPHISM
> >

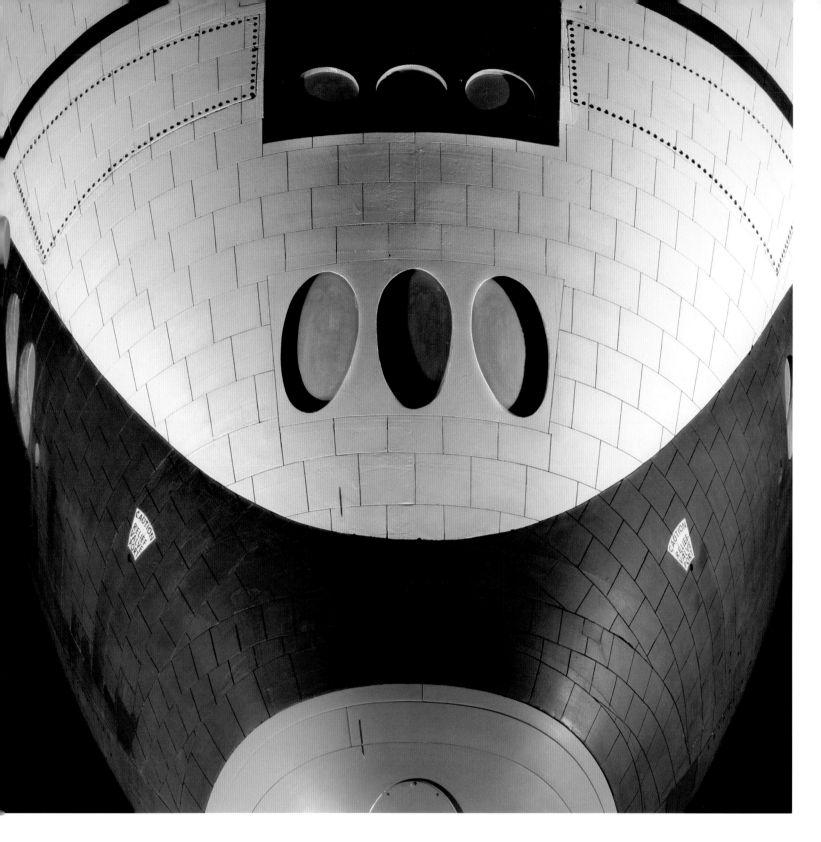

Space Shuttle Enterprise

"I've got special problems for every airplane. They've all got their own personalities and they're all very special."

—*Joe Engle*
Test pilot for the Space Shuttle Enterprise

Picking up on the intimate relationships pilots experience with their aircraft, which become extensions of the body and the mind, Russo teases out the lifelike attributes of a wide range of Smithsonian aircraft. The Kreider-Reisner C-4C Challenger becomes a delicate dragonfly, with its shimmering white body floating against a dark backdrop. Frog-like shapes dance around a pool in Russo's rendition of the interior of the Lockheed F-104A Starfighter engine. The tail of the World War I SPAD XVI is transformed into a delicate pair of moth wings, with markings resembling those of a Holstein cow. In the row of exhaust stacks along the green fuselage of the Supermarine Spitfire Mk. VIIc, Russo imagines organic flora—blades of grass or perhaps a row of wildflowers.

In other instances, aircraft become even more human in appearance. Russo's photograph of the exhaust pipe of the McDonnell F-4S Phantom II draws us in with features that suggest huge eyes, a long nose, and a horizontal mouth. An engine exhaust cone from the Arado Ar 234 B Blitz emerges like a delicately curved breast. The camouflage pattern on the Aichi M6A1 Seiran mimics the curves of a female body. The vortex generators of a Lear Jet 23 resemble a highly magnified strand of human hair—or a thorny surface that could prick the skin. A segment of Skylab, with its pairing of curved and rectilinear shapes, evokes a human couple whose forms have been abstracted into metal, just as the ancient Egyptians transformed royal couples into stone. The veins and pulsating heart of the human body come to mind as one gazes on Russo's view of the Soyuz Instrument Module. And human footsteps—like those left on the surface of the Moon—seem to be alluded to in this depiction of the North American F-86A Sabre.

from an interview with *National Geographic* at the National Air and Space Museum's Steven F. Udvar-Hazy Center, 2003

>>*Nose*

The brickwork pattern on the shuttle's surface is made of heat shield tiles that protect the spacecraft during reentry. The oval shapes are openings for thrusters, which pitch the nose up or down, yaw it right or left, or roll the vehicle.

>>see P.30-31 for more.

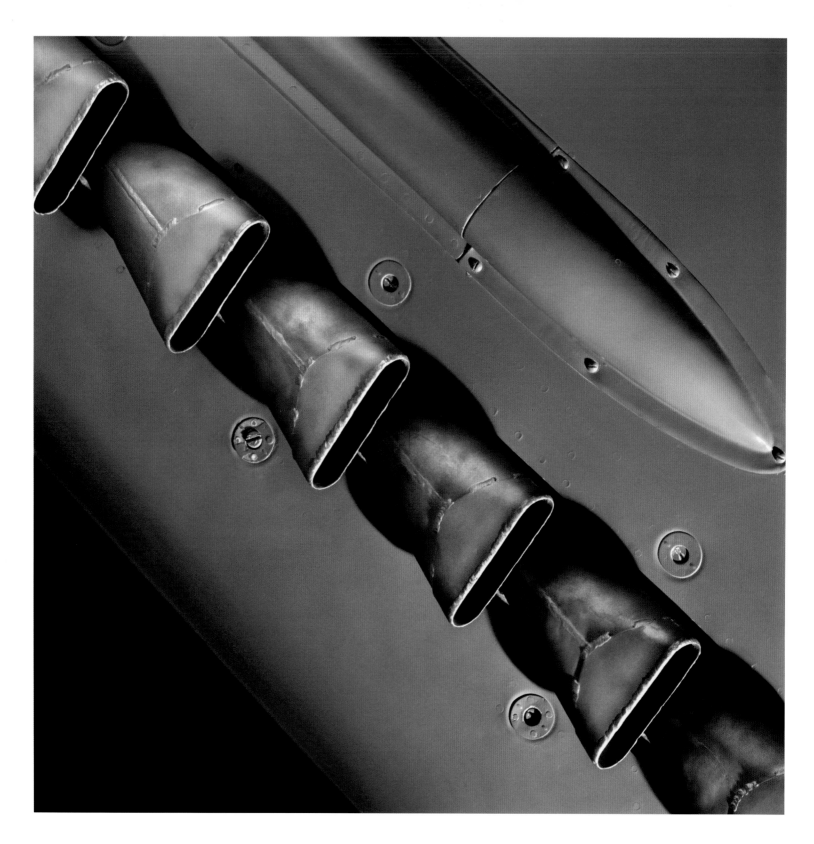

Supermarine
Spitfire Mk. VIIc

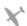

>>Engine Exhaust Stacks

The flattening of the Spitfire's 12 exhaust pipes increased the speed of the escaping gas. This provided a small but significant increase in thrust, adding almost 5 miles per hour.

The great air racing competitions of the 1920s and 30s were an important proving ground for aeronautical advancements later incorporated into civil and military aircraft. The Supermarine S.6B, the seaplane racer that gave Britain its final win in the prestigious Schneider Trophy Race in 1931, introduced many of the design elements that would ultimately evolve into the famous Spitfire.

With war looming in Europe, Britain needed a home defense interceptor, and Supermarine's racing designs fit the need. The Spitfire's elliptical wing reduced drag and increased speed. A Rolls-Royce Merlin provided the engine power, and eight machine guns, or later cannons, provided firepower. Excellent handling and maneuverability, and an ability to get airborne fast, were critical virtues as well.

Along with the Hawker Hurricane, the Spitfire earned lasting fame by defending against Germany's aerial assault in the Battle of Britain. Spitfires later evolved into other roles. Equipped with drop tanks, they served as bomber escorts. Others were modified for armed photo-reconnaissance missions or for high-altitude or low-altitude combat. Some were used for sea-air rescue operations. The Spitfire was the only airplane in continuous production throughout World War II.

Kreider-Reisner
C-4C Challenger

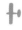

>>Tail

The tail assembly shows the structural elements of early aircraft. Wire and wooden braces strengthen the unmoving part of the horizontal stabilizer and help prevent flutter.

Ammon Kreider and Lewis Reisner, who operated a flying and airplane repair service, wanted to build a better airplane than the old Jennys and Standards that most pilots were still flying after World War I. So in 1926 they formed Kreider-Reisner Aircraft Company in Hagerstown, Maryland, and went to work.

Kreider-Reisner developed a series of aircraft called Challengers—three-place, open-cockpit biplanes with fabric-covered steel tubing and wood frames—which proved to be reliable, efficient, and eminently flyable. Their reputation soon caught the attention of Fairchild Airplane Company, which bought Kreider-Reisner in April 1929 and continued the design, redesignating the final Challenger model, the C-4C, as the Fairchild KR-34C. The line had a short lifespan, however, as six months later the stock market crashed. Only about 60 of the popular and versatile airplanes were built.

Before vanishing into aviation history, the C-4C made a respectable showing in the National Air Tour. Held each year from 1925 to 1931, the tour was an efficiency contest (it was initially called the Commercial Airplane Reliability Tour). Its purpose was to promote commercial aviation and to encourage towns and cities to build airports. In the 1929 tour, one C-4C served as the official press plane, and another placed eighth against formidable competition.

North American F-86A
Sabre

>>Machine Gun Ports

Inset machine gun ports are located in the
nose of the aircraft. The Sabre was armed
with six forward-firing .50 caliber machine
guns, three on each side of the fuselage. The
lines of dots are rivets, whose heads are flush
with the metallic skin to help reduce drag.

>>see P.27 for more.

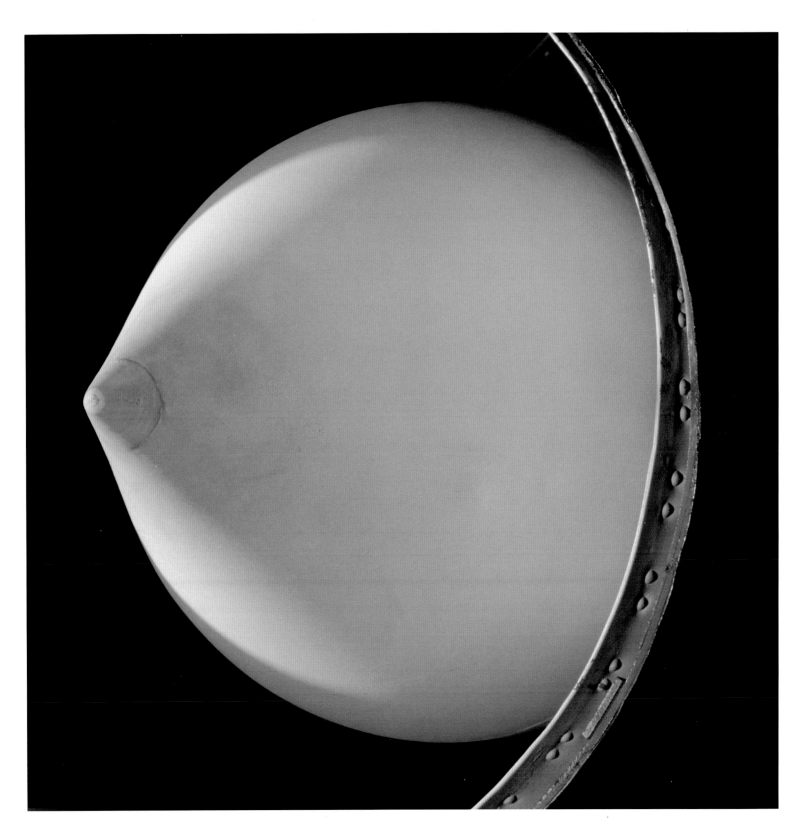

Arado Ar 234 B Blitz

>>*Engine Exhaust Cone*

The variable exhaust cones reduced turbulence at the aft end of the engine. They were nicknamed "onions" by German ground crews because of their shape.

During World War II, Germany not only built the first operational jet fighter, the famous Messerschmitt Me 262, but also the first operational jet bomber and reconnaissance aircraft, the lesser-known Arado Ar 234 B. Capable of speeds up to 450 miles per hour, the Arado could easily outrun Allied interceptors.

Development began in 1940, but the Me 262 received priority for the delivery of turbojet engines, so production

versions of the Ar 234 didn't appear until 1944. Two Junkers Jumo turbojets powered the high-wing aircraft. One version had a pair of reconnaissance cameras mounted in the rear; another could carry a 1,000-kilogram bomb load. The pilot also served as bombardier, using a bombsight mounted ahead of the control column (which swung aside) and an autopilot. A few advanced Ar 234 C versions were produced, powered by four

engines and featuring pressurized cockpits. They were the fastest jet aircraft of the war.

The first Ar 234 combat mission was a reconnaissance flight over the Normandy beachhead two months after D-Day. Arados carried out bombing and reconnaissance missions on both eastern and western fronts until Germany's surrender. Fewer than 250 Ar 234s were built; only this one remains.

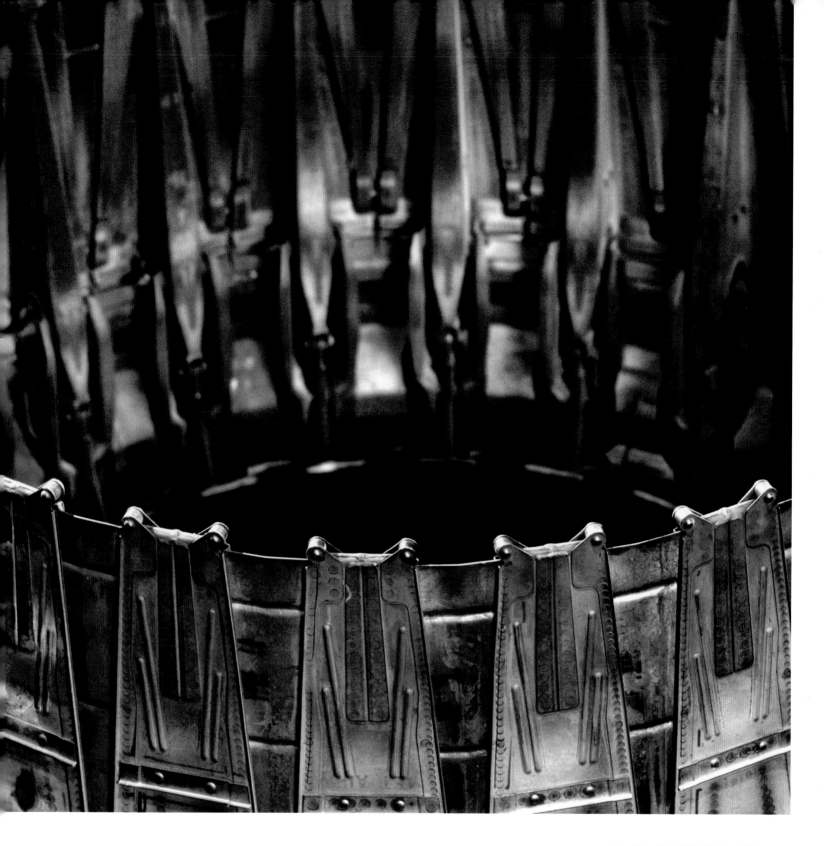

Lockheed F-104A Starfighter

"Advancing technology creates, in itself, new problems for research to solve, so that research advances the technology, the technology requires more from research, and we have an unending chain reaction."

—*Jerome Clarke Hunsaker*
Aeronautical engineer and former head of the Departments of Aeronautical Engineering
and Mechanical Engineering at the Massachusetts Institute of Technology

from the film outtake of *We Saw It Happen*, 1953

>>Exhaust Nozzle

When the engine's afterburner fires up, the additional heat and thrust cause the tail pipe to open wider, like a male turkey spreading its feathers. This "turkey feather" mechanism closes again when the afterburner shuts down.

The slender F-104 was the first U.S. interceptor to fly at sustained speeds above Mach 2, twice the speed of sound. Unlike most jets, the Starfighter had small, straight wings, whose leading edges were so sharp that ground crews fitted special covers over them to prevent injuries. The wings were set far back and angled downward, and the fuselage tapered to a needlelike point at the nose. Little wonder that the Starfighter was dubbed "the missile with a man in it."

A prototype first flew in 1954, and four years later production versions began slicing through the sky. Pilots lost no time setting records with the powerful aircraft, including a new world altitude record of over 91,000 feet and a world speed record of 1,400 miles per hour. F-104s also broke four old climb-to-height records and set three completely new ones.

Most Starfighters were flown by other nations, although some served with the Air Force into the 1960s and the Air National Guard until 1975. The one acquired by the National Air and Space Museum was used by NASA as a test bed and chase plane and for flight research that led to the X-15 program. Among those who flew it were seven X-15 pilots and three Apollo astronauts, including Neil Armstrong, the first man to walk on the Moon.

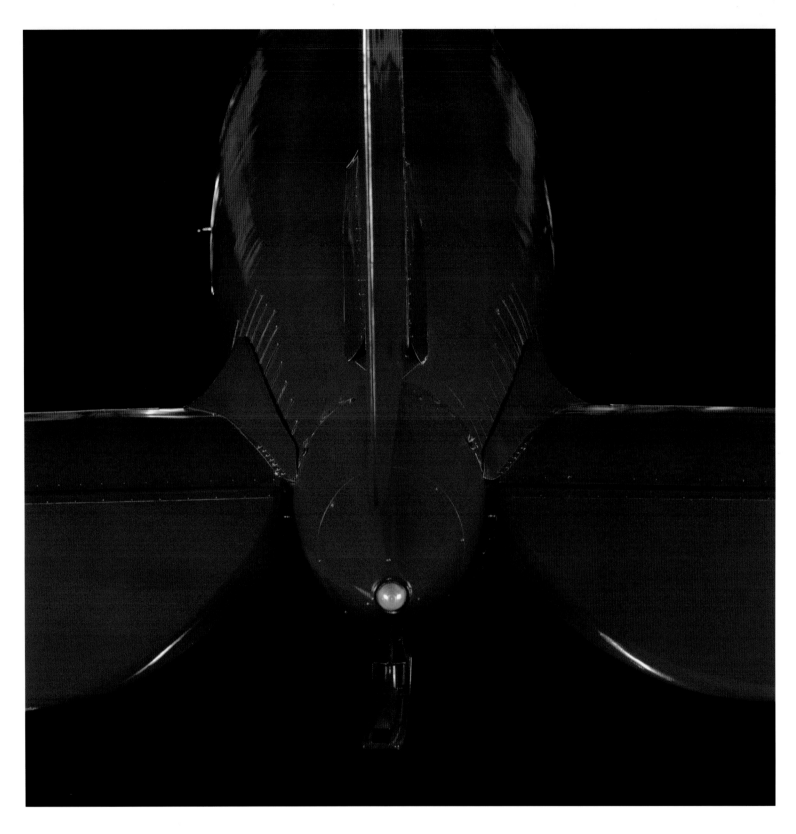

Lockheed 5B Vega

>>Tail

Easily visible: the small white navigation light
and tail skid below it. Less visible: 10 vertical
strips of leather on both sides just above the
concave wing fillet and horizontal stabilizer.
The pilot could adjust the stabilizer up or
down along these strips to "trim" the aircraft.

In the late 1920s and early 1930s, the
airplane began to assume its modern
appearance and structure. One of the first
airplanes we might recognize as modern
looking was the Lockheed Aircraft
Company's first product, the Vega.

The Lockheed Vega featured a spruce
cantilever wing (no drag-producing
external wires or struts needed for support),
and it reintroduced the streamlined
monocoque fuselage, first used on a French

Deperdussin racer years before. The
shell-like molded plywood fuselage didn't
require internal bracing, made the aircraft
more robust, and provided more useful
open space inside. Engines on later
versions were covered with a cowling
developed by NACA (National Advisory
Committee for Aeronautics), which
greatly reduced drag and improved
engine cooling. All these innovations
became standard on most airplanes.

The bright red Vega pictured here is
particularly historic. Amelia Earhart owned
it and used it for two notable record flights.
In May 1932 she flew it across the Atlantic
from Newfoundland to Northern Ireland
to become the first woman to cross the
Atlantic alone, and the first solo pilot to
do so since Charles Lindbergh in 1927.
Later that year she flew the Vega from Los
Angeles to Newark, New Jersey, the first solo
nonstop transcontinental flight by a woman.

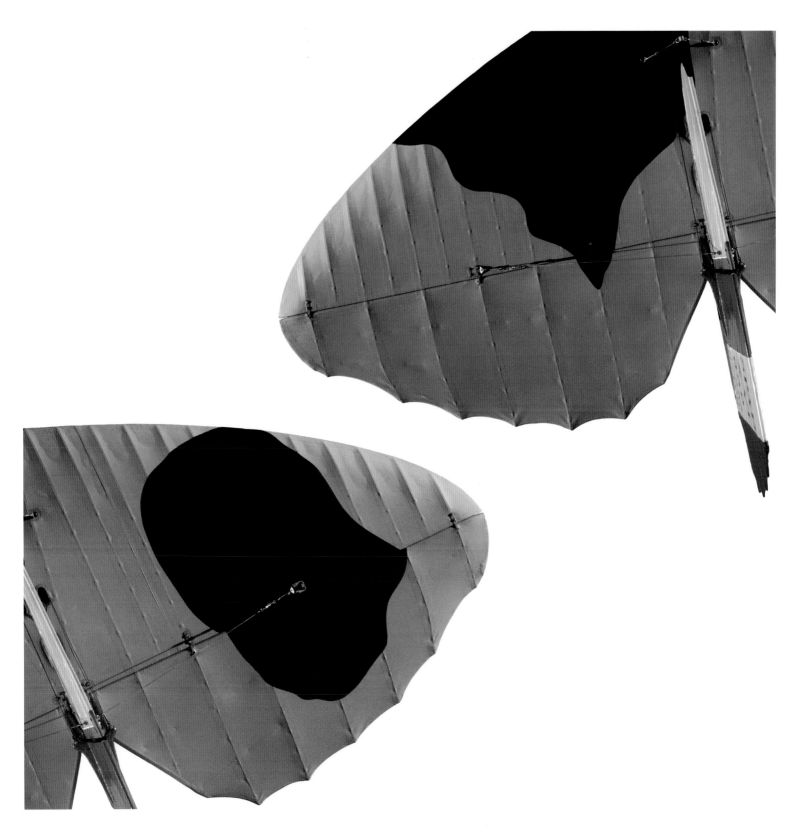

SPAD XVI

>>*Tail*

The aircraft was painted with irregular patches of autumn colors to camouflage it.

The French company known by the acronym SPAD built some of the best fighter planes of World War I, most notably the SPAD VII and XIII, which were known for their speed, ruggedness, and diving ability.

The SPAD XVI, on the other hand, proved less endearing. It evolved from the SPAD XI, a two-seat version of the VII and VIII. The pilot controlled a fixed, forward-firing Vickers machine gun, while the gunner behind him fired a pair of Lewis machine guns on a flexible mount. The SPAD XI's maneuverability and handling left much to be desired, and the airplane tended to stall at inopportune moments. The SPAD XVI tried to improve upon that design, with a Lorraine-Dietrich engine instead of a Hispano-Suiza and a slight backward sweep to its wings, but it didn't handle any better. On the positive side, in the event of a fire, the pilot could dump the fuel in the main tank beneath his seat, so his airplane would burn up a bit less quickly.

The SPAD XVI's considerable short-comings didn't deter American Brig. Gen. William "Billy" Mitchell from acquiring one and flying it on observation missions over the front lines late in the war. And he trusted it enough to take the Prince of Wales up for a ride in it after the Armistice.

This Spad XVI, serial number 9392, was Mitchell's personal aircraft and is equipped as it was during the war.

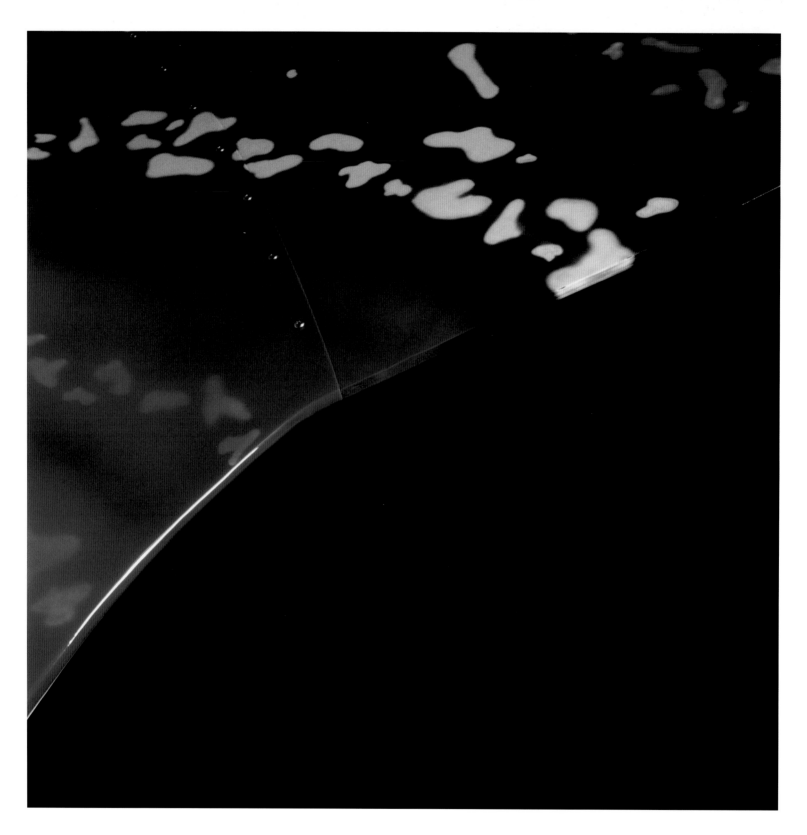

Sukhoi Su-26M

>>Wing

The high-performance composite wing can handle the ultimate load of +12 and -10 Gs used in extreme aerobatics. The aircraft is adorned with an elaborate custom paint scheme that masks its Russian origins.

In the early 1980s, Soviet fighter plane designers at the Sukhoi Design Bureau turned their engineering talents toward producing an aircraft for unlimited aerobatic competition. The resulting Sukhoi Su-26M rolled out in 1984 and entered competition later that year with the Soviet national aerobatic team. It was not long before Soviet and Russian pilots began capturing aerobatic titles in international competitions. Sukhois proved so successful that many European and American competitors now fly them as well.

The Su-26M is made in large part of lightweight composite materials. Strongly constructed, the aircraft can handle forces ranging from +12 Gs to -10 Gs brought on by the spectacular maneuvers it can perform. The pilot's seat is inclined at 45 degrees to enable the pilot to survive those kinds of forces as well, without blacking out. The aircraft is so light and powerful it can nearly hang in mid-air from its propeller.

The Sukhoi Su-26M that ended up at the National Air and Space Museum once sported "Russian purple" and flew more than 200 times for the Soviet national aerobatic team in 1990 and '91. American aerobatic pilot Gerry Molidor later bought the airplane and flew it in competitions and air shows in its colorful "Bud Light" paint scheme.

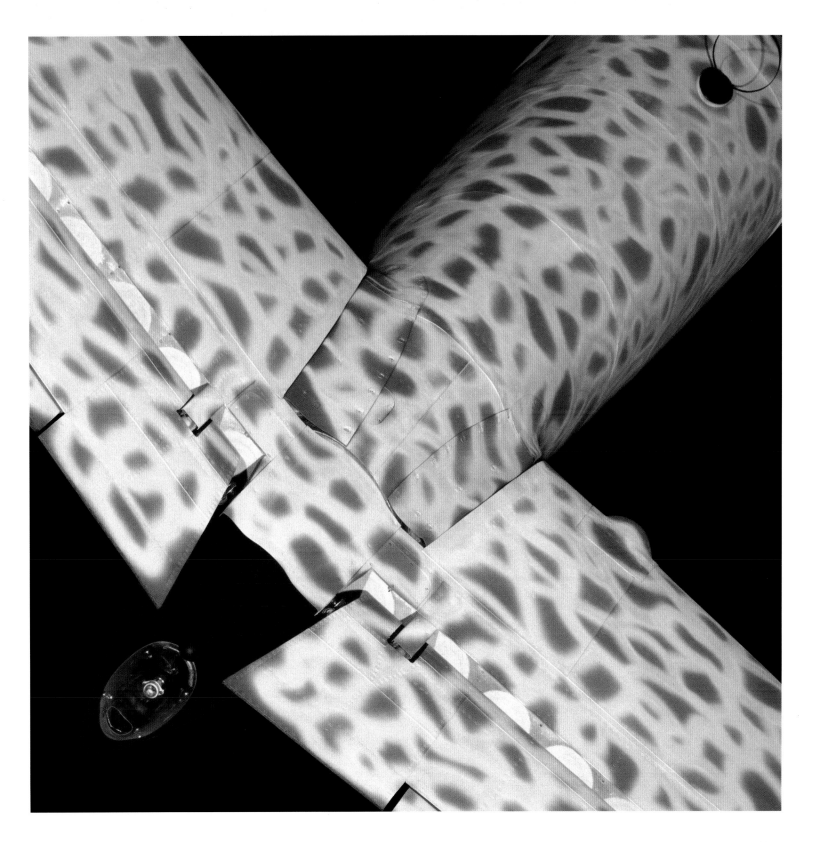

Heinkel He 219 A Uhu

>>Rear Fuselage

This view from above shows the navigation light, the rear fuselage, and the inboard section of the horizontal stabilizer. The camouflage pattern typical of German night fighters made the aircraft difficult to see at night.

German for "eagle owl," Uhu was an appropriate name for an aircraft designed to seek out its prey in the dark—a night fighter. The Royal Air Force bombers pounding Germany by night were the prey it was after. The means for spotting them was the radar an Uhu carried in its nose.

The He 219 and the American Northrop P-61 Black Widow were the only World War II aircraft actually designed for the night fighter role. The He 219 boasted several advanced features. It was the first German aircraft with a steerable nose wheel and the first operational aircraft with ejection seats for its two crew members. Its heavy armament included a pair of 30 mm cannons angled upward for attacks from below, where a bomber was most vulnerable.

Not as keen, relatively speaking, as an owl's eyes, the aircraft's radar could only pick up a target within a limited field of coverage and just a few miles ahead. Mid-air collisions with unseen targets were not uncommon. Still, the He 219 and other German night fighters inflicted terrible losses on British bombers. Germany managed to build fewer than 300 He 219s before the war ended.

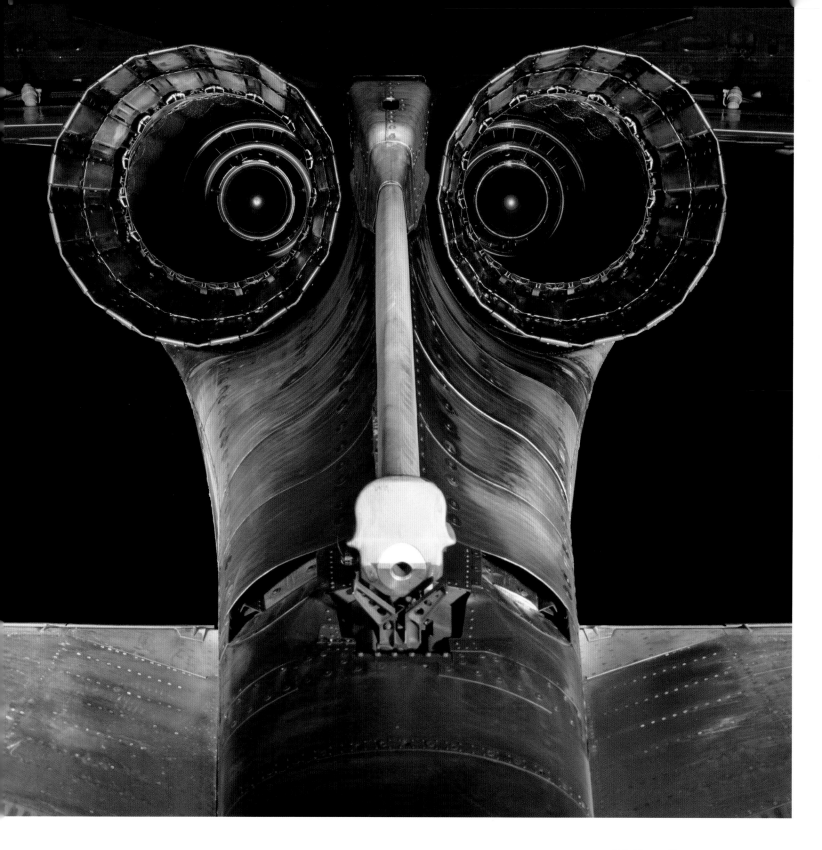

McDonnell
F-4S Phantom II

"The Spirit of St. Louis is a wonderful plane. It's like a living creature, gliding along smoothly, happily, as though a successful flight means as much to it as to me, as though we shared our experiences together, each feeling beauty, life, and death as keenly, dependent on the other's loyalty. We have made this flight across the ocean. Not I or it."

—*Charles Lindbergh*
First pilot to complete a solo crossing of the Atlantic Ocean

from *The Spirit of St. Louis*, 1953

>>Tail (inverted view)

The circular piping of the afterburners can be seen inside the dual jet engine exhausts. The tail hook, in its retracted position, is nestled between them. When extended the tail hook is used to snag an arresting cable during aircraft carrier landings.

The alphabet soup of letters and numbers that can be found following the designation "F-4" testify to the dizzying number of Phantom II versions produced over the span of two decades. They began in 1958 with the F4H-1, the U.S. Navy's first carrier-based aircraft that could reach Mach 2. By 1979, when production ended, more than 5,000 F-4s had been built. They continued to operate on Navy carriers until 1986.

Versatility was the hallmark of the F-4 Phantom. It could carry one or two crewmembers, serve as a carrier- or land-based aircraft, carry air-to-air or air-to-ground missiles and a load of bombs, or fly unarmed as a reconnaissance aircraft. The basic Phantom F-4B could reach a maximum speed of nearly 1,500 miles per hour at 45,000 feet. The F-4S was an extensively modernized later version.

Phantoms served with great distinc-tion during the Vietnam War, and both the U.S. Navy Blue Angels and U.S. Air Force Thunderbirds flight exhibition teams chose to fly Phantoms in the late 1960s. Ultimately, Phantoms served with the Air Force, Navy, Marine Corps, and the air forces of 12 other nations, includ-ing Great Britain, South Korea, Spain, Australia, Israel, Japan, and West Germany.

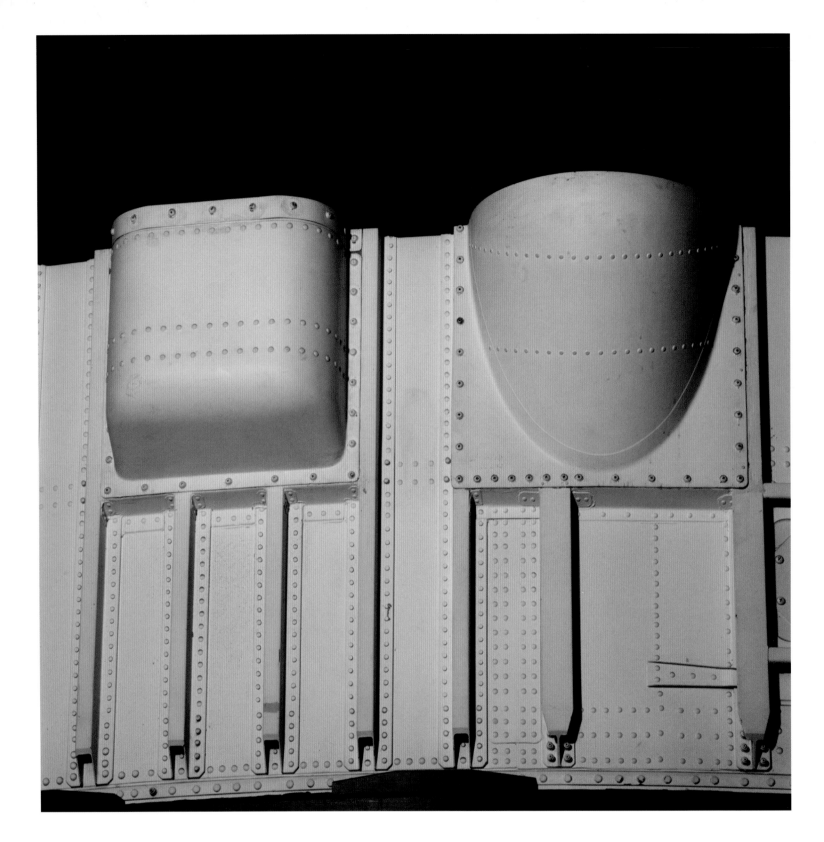

Skylab Orbital Workshop

>>Aerodynamic Fairing

The Skylab orbital workshop structure was a modified stage of a Saturn V launch vehicle. These two endcaps cover electrical cables and tubes that run along the exterior and penetrate the skin of the rocket-turned-workshop.

>>Storage Tanks

More than 20 titanium spheres attached to
one end of the spacecraft contained
nitrogen for the attitude control thrusters
that kept the huge Skylab Space Station
stable and maneuverable.

America's first space station, Skylab was
launched into orbit in 1973. Three groups
of three astronauts occupied it over the
next year. The first group stayed about a
month, the second for two months, and
the third for 84 days, a U.S. record for
duration in orbit that stood for 22 years.

Two Skylabs were built, but only one
was launched. The orbital workshop
module, the largest section and where the
crews lived and worked, was made from

the third stage of a Saturn V launch
vehicle left over from the Apollo program.
Skylab also had an airlock for exiting into
space, a port where the Apollo spacecraft
bringing the crew would dock, a solar
observatory, and large solar panels. Skylab
was roomy and comfortable compared to
previous spacecraft, more like a house
than a space capsule, with a large window,
a galley/wardroom, private sleeping
quarters, and even a toilet and shower.

Skylab's scientist-astronauts studied the
Earth and Sun, materials processing in
microgravity, the effects of weightlessness on
the human body, and crew adaptation to
prolonged spaceflight. When NASA's efforts
shifted toward the Space Shuttle, the Skylab
program was canceled. NASA allowed
the space station's orbit to decay, and
Skylab burned up when it reentered the
atmosphere in 1979. The second (backup)
Skylab is on display in the Museum.

Aichi M6A1 Seiran

"Learning the secret of flight from a bird was a good deal like learning the secret of magic from a magician. After you once know the trick and know what to look for, you see things that you did not notice when you did not know exactly what to look for."

—*Orville Wright*
Inventor of the airplane, with his brother Wilbur Wright

from *The Papers of Wilbur and Orville Wright,
Volume Two: 1906–1948*, 1953

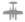

>>*Aircraft Marking and Camouflage
Scheme*

The red "rising sun" on the fuselage
symbolizes Japan. The dark-colored top of
the airplane blended with the sea when seen
from above, and the light-colored bottom
blended with the sky when seen from below.

One of the most ingenious weapon
systems Japan developed during World
War II was the submarine-launched
bomber, designed to strike distant
strategic targets. The project required
developing aircraft that could be
dismantled and stored in a confined
space on submarines that would transport
and launch them.

The aircraft, the Aichi Seiran, was
launched by catapult and armed with
either a bomb or torpedo. For storage in a
waterproof compartment, the main wing
spar rotated 90 degrees and the wing
folded back against the fuselage. Parts of
the tail stabilizers also folded, and the
floats used in training were removed. A
submarine crew could assemble and
launch the aircraft within 30 minutes.

The first Seiran prototype was
completed in late 1943 and the first
submarine at the end of 1944. But
production of both aircraft and
submarines was curtailed due to
manufacturing disruptions during
wartime. Of the 26 Seirans produced, all
were destroyed except this one, which
was recovered on the Japanese mainland
after the war.

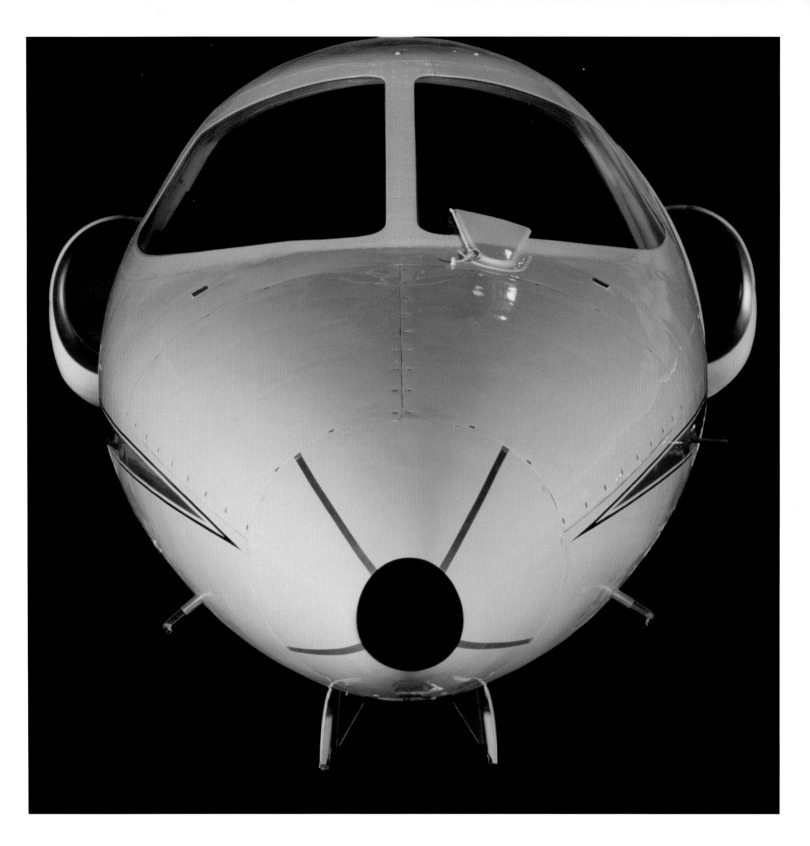

Lear Jet 23

>>*Fuselage*

This front view of the fuselage shows the radar dome in the center and two pitot tubes on each lower side. The two engines can be seen in the rear.

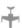

Rows of small plates above and below the outer wing create tiny whirlpools (vortexes) in the airflow. The vortexes help maintain a smooth flow of air over the aileron control surfaces at low speeds, as when coming in for a landing.

The inspiration of William P. Lear Sr., the Lear Jet helped launch the fields of business and personal aviation. The compact jet could transport travelers quickly over long distances, cruise above the weather in pressurized comfort, and land at airports large or small. The Model 23 was the first and smallest of the breed; it could carry up to nine people.

The Lear Jet Corporation unveiled the prototype of its founding product in 1963. The aircraft structure was based on a military aircraft, the Swiss AFA P-16 strike-fighter. The Lear Jet incorporated the cutting-edge design concept known as area rule—the fuselage narrows where the wing and engine nacelles are attached, which reduces drag at high speeds. Equipped with a pair of powerful GE turbojets, the Model 23 could out-climb an F-100 Super Sabre fighter to 10,000 feet.

Lear Jets became a hit not only in the business and private aviation spheres, but also with pilots bent on setting records. Lear Jets had barely started rolling out of the factory when they began toppling distance, speed, and climb-to-altitude records. In 1976 golf legend Arnold Palmer and James Bir set a round-the-world speed record of just under 49 hours with a Model 36. The Bombardier company acquired the venerable line in 1990.

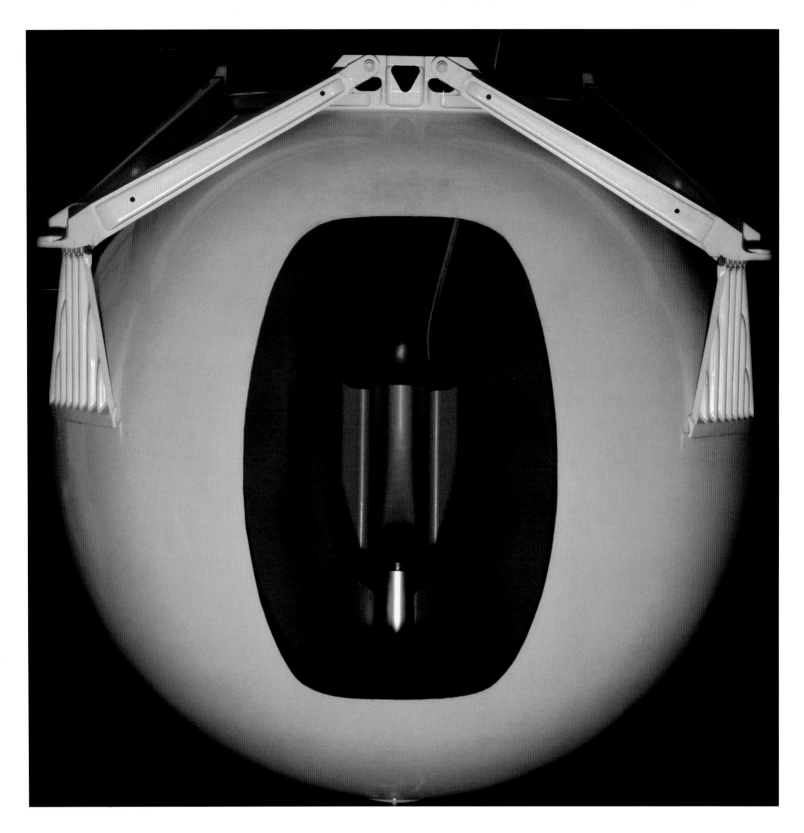

Surveyor Retrorocket Motor

>>Solid Propellant

>>Solid Propellant

This cutaway section view shows the simulated solid propellant of the retrorocket motor and the igniter device in the middle. Propellant combustion produced exhaust gases, which provided thrust for a gentle landing on the Moon.

While manned missions into Earth orbit were taking place in the 1960s in preparation for sending humans to the Moon, a parallel program of unmanned lunar exploration was also underway. Technologies for reaching and landing on the Moon had to be tested, landing sites determined, and the nature of the lunar surface investigated. Scientists were not even sure whether the lunar surface could safely support a spacecraft. Robotic explorers were sent to find out.

NASA launched seven Surveyor spacecraft from 1966 through 1968, and five landed successfully on the Moon. They transmitted back to Earth tens of thousands of television pictures, scooped up samples of lunar soil and analyzed its composition, and performed other experiments. They also confirmed that the lunar surface could support the weight of a landing craft and a Moon-walking astronaut.

But Surveyor first had to decelerate from nearly 6,000 miles per hour to a speed low enough to ensure a gentle landing. A solid-fuel retrorocket motor fired when Surveyor was less than 50 miles from the surface, burned for about 39 seconds, and slowed the spacecraft to less than 300 miles per hour. The main retrorocket was then ejected, and smaller rocket motors slowed and guided Surveyor to a soft landing.

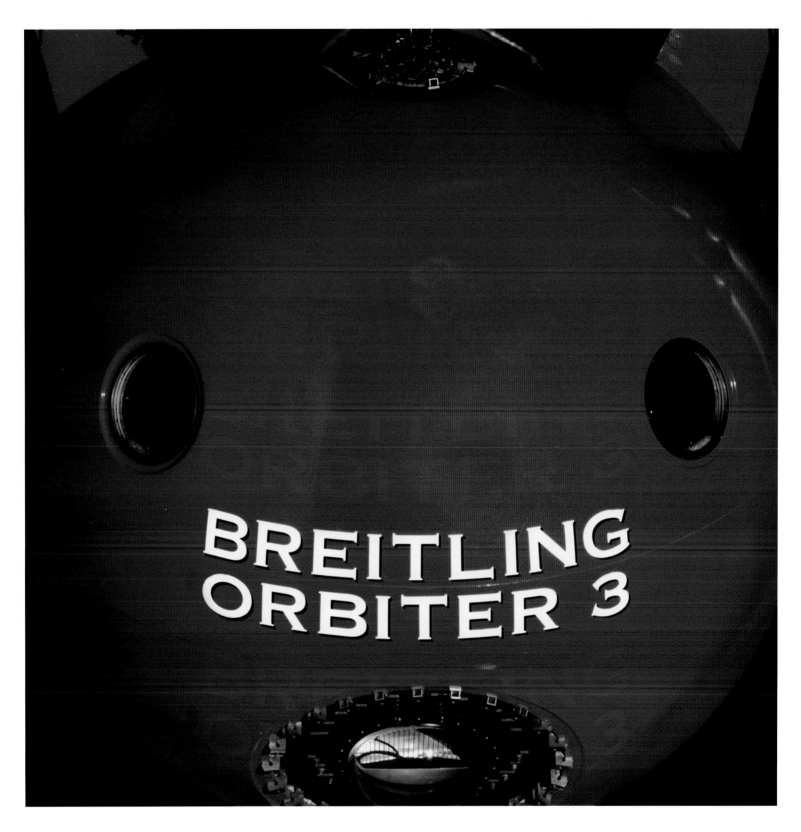

BREITLING
ORBITER 3

Breitling Orbiter 3

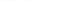

>>*Cockpit End of the Gondola*

The cockpit section of the "Tylenol capsule"-shaped gondola was outfitted with windows, two sets of bunk beds, various equipment, and a head. The circular windows allowed for a view outside of the gondola's "shirt-sleeve" environment.

On March 21, 1999, Bertrand Piccard and Bryan Jones landed their Breitling Orbiter 3 balloon in the Egyptian desert, ending a 20-day flight that took them completely around the world without stopping, a first in the history of lighter-than-air flight. Sixteen unsuccessful attempts had been made to circle the globe by balloon since 1980. But with the Breitling Orbiter 3, "the last great aviation challenge of the century" had

finally been met, nine months before century's end.

The day-glow-red gondola, made of Kevlar and carbon fiber material, was about as roomy as a small recreational vehicle. Although it was heated, temperatures sometimes fell so low that ice formed in the pressurized cabin. Solar panels beneath the gondola recharged the on-board batteries that provided electrical power. The pilots used satellite-

based systems to communicate and navigate.

The balloon was a technological hybrid, using both helium and hot air to stay aloft. Its six burners were fueled by 28 canisters of propane gas, four of them added just before takeoff. By the time Piccard and Jones landed, they had less than a quarter of a single tank left.

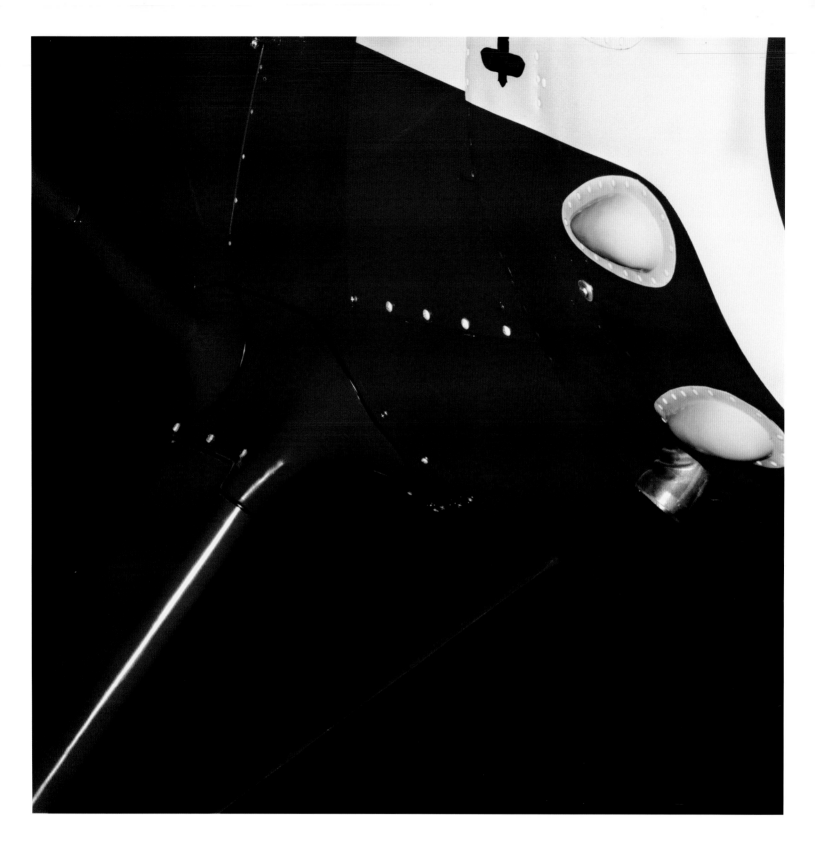

Monocoupe 110 Special
Little Butch

Don Luscombe's line of Monocoupe
aircraft evolved from the Monocoupe 22,
a business or personal aircraft with two
side-by-side seats in an enclosed cockpit.
Introduced in 1928, the high-wing
monoplane was lighter and far more
comfortable than open-cockpit biplanes.
The 1930s brought the 70, 90, and 110
models, the aerial sport coupes of their
time, each bearing the Monocoupe's
sporty reverse-curve rear fuselage lines.

Fast and maneuverable and driven by a
powerful Warner Scarab radial engine, the
Monocoupe 110 proved a winner on the
aerobatic and air racing circuits. The few
Monocoupe 110s designated Specials had
shorter wings, a smaller tail, streamlined
fairing and wheel pants, and an even more
powerful Scarab, making them considerably
faster and adept at flying tight, high-speed
turns around racing pylons.

Little Butch rolled out in 1941 and

survived a succession of owners; the last,
John McCulloch, claimed he was only
owner who never flipped the airplane
onto its back. But despite accidents and
mishaps, *Little Butch* had its glory days.
Aerobatic pilot "Woody" Edmonson, who
gave the bulldog-like airplane its name,
flew it to second place in the 1946 and
'47 American Aerobatic Championships
and to first place in the 1948 Interna-
tional Aerobatic Championship.

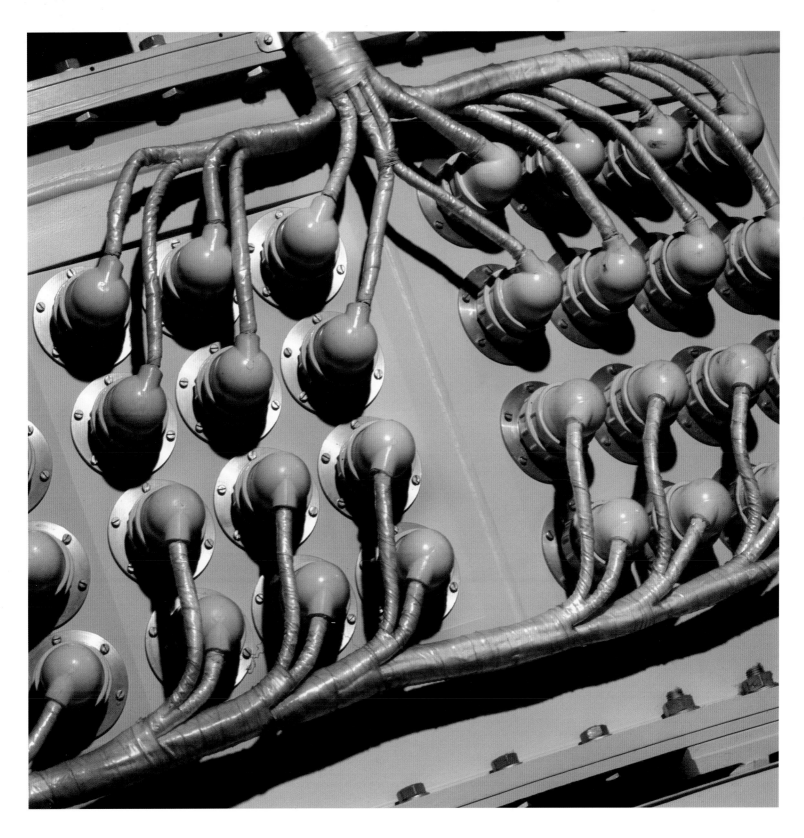

Soyuz Instrument Module

>>*External Wires for the Spacecraft Systems*

The wires and connections are tightly covered and capped to reduce the effect of vibrations during launch and reentry.

Cold War relations between the United States and the Soviet Union thawed long enough in the early 1970s for the two nations to cooperate in a joint manned space mission. The Apollo-Soyuz Test Project involved launching a U.S. Apollo and a Soviet Soyuz spacecraft, the two craft rendezvousing and docking in orbit using a jointly engineered docking module, and the crews meeting and sharing a few days together in space. The 1975 mission was a welcome exchange of goodwill between the rival nations, and it set a precedent for future U.S.-Russian cooperation in space.

Soviet engineers designed the Soyuz during the Space Race of the 1960s. The first Soyuz cosmonaut flew into space in 1967, and subsequent generations of the workhorse spacecraft have been used in Earth orbit ever since.

Like the Apollo lunar spacecraft, the Soyuz has a three-part modular design. The spherical orbital module at the front serves as storage space during launch and as workshop and living space in orbit. The bell-shaped landing module just behind it houses the crew during launch and reentry; it is the only part that returns to Earth. The cylindrical instrument module at the rear contains the main spacecraft systems: propulsion, heating, cooling, and communications.

The Soyuz Instrument Module at the Museum is a mock-up and was never flown.

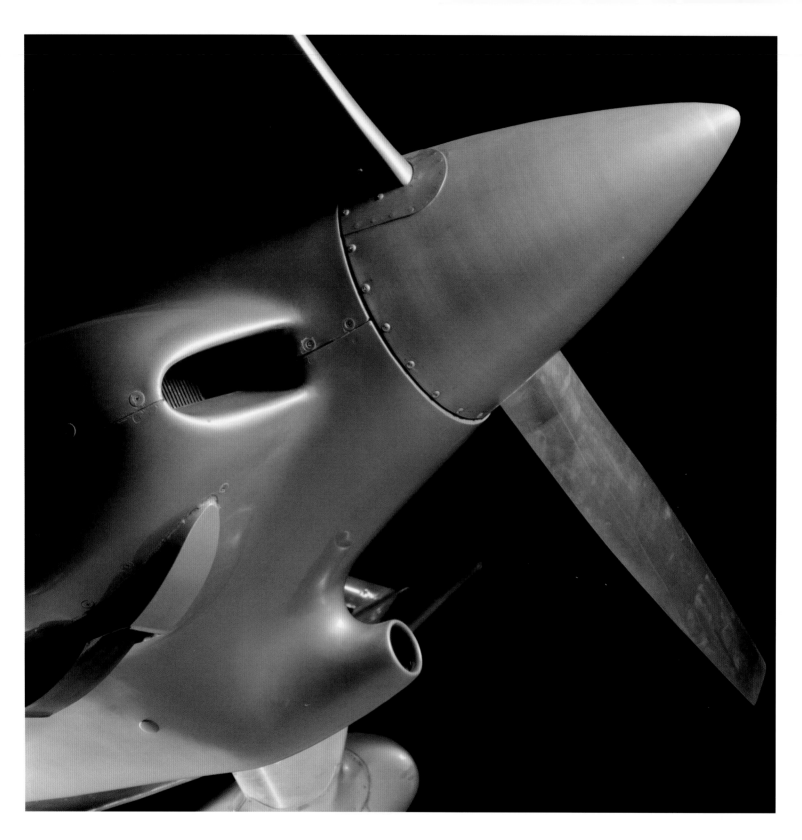

Mahoney Sorceress

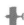

>>Nose Section

This side view of the nose section shows the propeller spinner and engine air intakes. The small round circle is an intake for the carburetor.

The words "sleek biplane" may seem oxymoronic, but then there was never another biplane like the Sorceress. Designed and built in 1969 by the father-son team of "Mickey" and Lee Mahoney, the Sorceress looks like no other biplane. It has a polished aluminum fuselage with an enclosed center cockpit. The lower of its two widely staggered wings is a deep inverted gull wing that rests on faired wheels. The airplane is streamlined from the point of its nose to the vertical blade of its rudder.

It looked and flew like a rocket with wings. Powered by a single 135-horsepower Lycoming engine, the Sorceress was the first sport biplane to exceed 200 miles per hour on a closed course, and it reached 245 miles per hour in level flight. It so outclassed its racing class throughout the 1970s that the competition qualification rules were changed, which ultimately forced the airplane into retirement. But not before the Sorceress racked up numerous wins in qualifiers, heats, and races, and set several world speed records.

Many of those wins and records came with air racing pilot Don Beck at the controls. Beck bought the airplane in 1972 and raced it at the National Championship Air Races in Reno through 1983, placing first or second in most of the events the Sorceress entered.

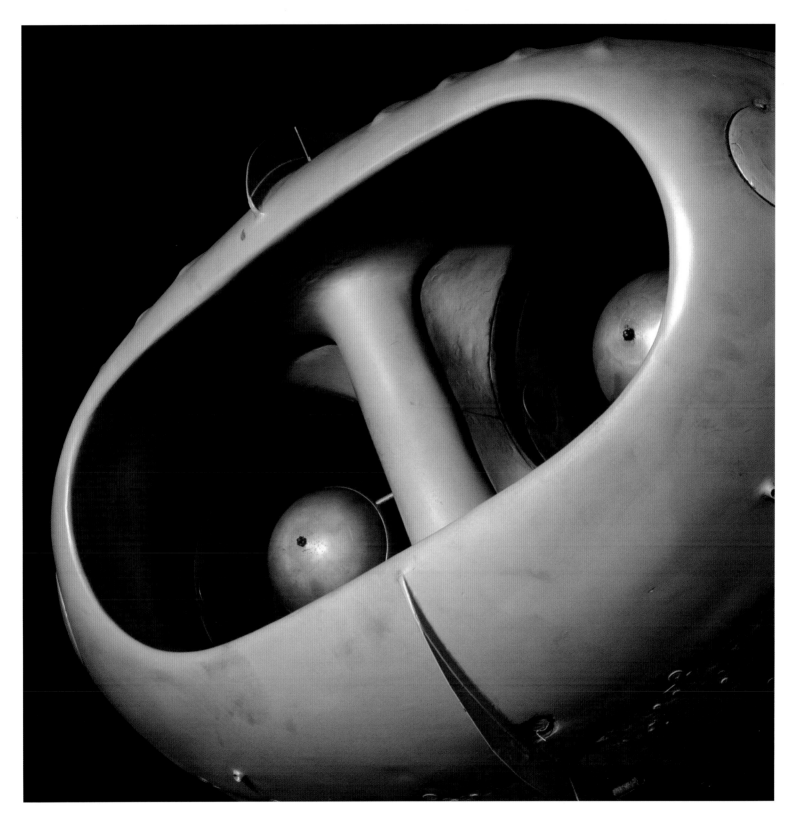

Hispano HA 200 Cairo

>>Engine Air Intake

The engine air intake for this aircraft allowed the air to reach the engines mounted behind the pilot.

The Spanish aircraft company Hispano and German designer Willy Messerschmitt (of Messerschmitt Bf 109 fame) teamed up after World War II to produce a new trainer/fighter for the Spanish air force. Their first product was the propeller-driven Hispano HA 100, followed in 1955 by a jet-powered version, the HA 200. Both were also offered by the Messerschmitt company as the Me 100 and Me 200.

The Saeta, or Arrow, as the Spanish called it, was powered by a pair of French-built turbojets and outfitted with two tandem seats for instructor and student in the pressurized cockpit. The armed attack models could carry machine guns, rockets, bombs, or auxiliary fuel tanks and had more powerful engines. The Spanish flew them in combat in North Africa.

In the late 1950s, Hispano granted a license to Egypt to build HA 200s for

their air force. The Egyptians named their version of the HA 200 the Al Kahira, or Cairo. They used them as trainers and possibly as fighters during the Six Day War with Israel in 1967. Several were destroyed on the ground, along with most of the rest of the Egyptian air force, during Israel's initial lightning air strike. A few Cairos were still in use years later as trainers and utility aircraft.

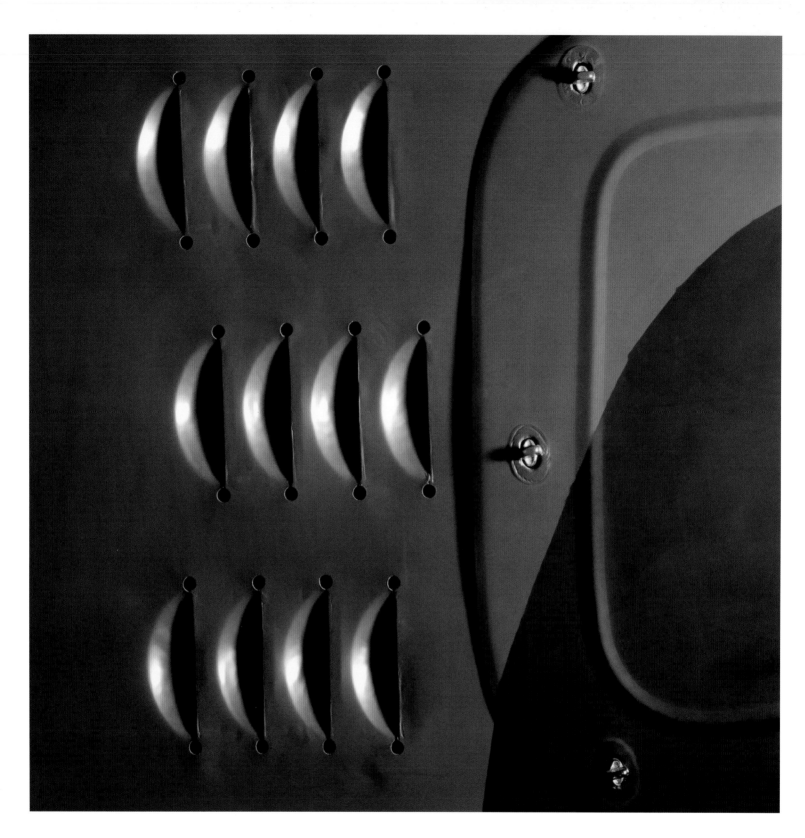

SPAD XVI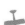

>>*Air Vents*

The air vents located on the SPAD's nose provided additional cooling for the water-cooled engine.

>>see **P.43** for more.

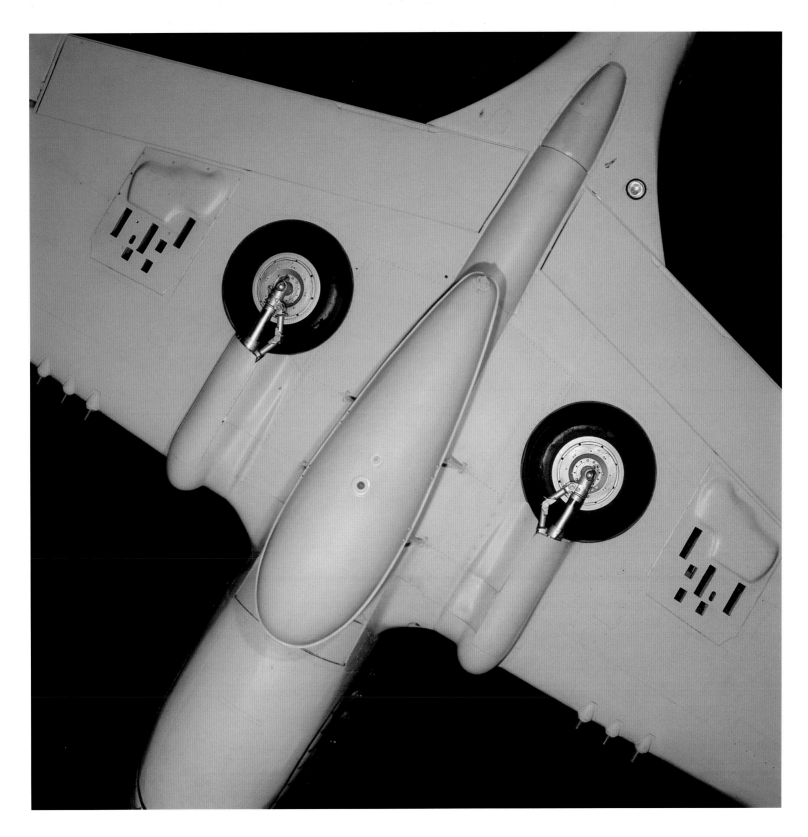

Curtiss P-40E Kittyhawk

>>Landing Gear

The underside of the plane shows the
retracted main landing gear, which unfolded
and turned 90 degrees for landing.

Known variously as Tomahawks, Warhawks,
and Kittyhawks, P-40s were not the finest
fighter planes of World War II, but they
were among the most numerous during
its early years. And those of one parti-
cular unit ranked among the most
renowned aircraft of the war.

That unit, the American Volunteer
Group, was organized by retired veteran
Capt. Claire Chennault, whom China had
hired to help organize its air defenses. Nine

months before Pearl Harbor, Chennault
received permission to recruit Americans
to fight in China against invading Japanese
forces. The group of volunteers he quietly
assembled slipped into the country and began
training with P-40s sent to China under the
Lend-Lease program. The fliers decided to
give their airplanes a distinctive paint scheme:
a shark mouth lined with teeth surrounding
the engine air intake. The Chinese back in
the States gave the unit the name Flying

Tigers, and the group and its fiercely
painted planes soon became famous.

The Flying Tigers flew their first
combat mission on December 20, 1941.
They had great success against the
Japanese along the Burma Road over the
next few months, but ultimately they
could not halt the enemy's advance. In
July 1942 the unit was replaced by the
Army Air Forces' 23rd Fighter Group,
which still carries the Flying Tigers name.

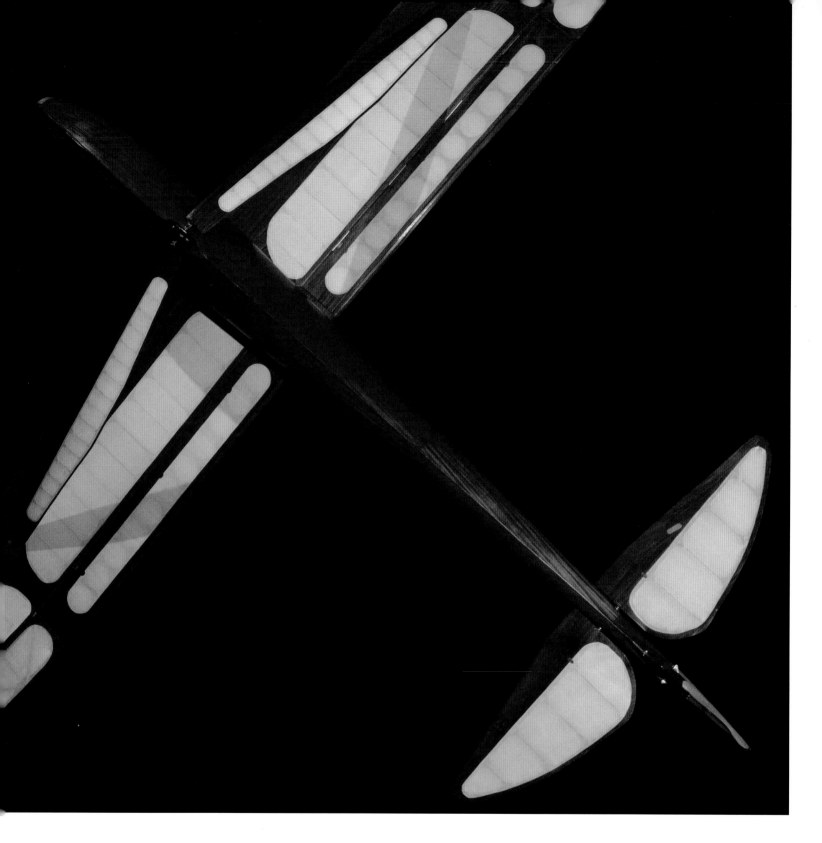

*Bowlus 1-S-2100 Senior
Albatross Falcon*

>>*Looking Up*

The Albatross sailplane was built of
mahogany and covered with cotton fabric.
The struts were made with internal wooden
ribs to keep the aircraft lightweight for
better performance.

"A bird is an instrument working according to mathematical law, which instrument it is within the capacity of man to reproduce with all its movements."

—*Leonardo da Vinci*

from *Treatise on the Flight of Birds*, 1505, from *Slipping the Surly Bonds*, 1998

The descriptive name came into being because this famous sailplane designer also created another sailplane named the "Baby Bowlus." It was smaller but still ranked alongside its bigger brother.

"Few flying machines have ever exhibited such an extraordinary combination of workmanship, finish, and aerodynamic refinement, so that it seems quite safe to say that the new ships represent the ultimate in soaring design practice in the United States, if not the world," wrote one enthusiast about the Senior Albatross in the July 1934 issue of *Aviation*.

That said a lot, given that Germans, not Americans, led the world in glider design at the time. William Hawley Bowlus, who developed the Senior Albatross from his earlier Super Sailplane, did borrow heavily from German designs—the wing, airfoil, control surfaces, and cockpit reflected this. Still, the final design was uniquely his own, handsomely finished with mahogany plywood covered with cotton fabric and graced with an elegant gull wing. Each of the four Senior Albatrosses he created differed slightly,

but all performed superbly. They set sailplane distance and soaring records and dominated soaring competitions for years.

Bowlus himself had an interesting background. He served as a factory manager for Ryan Aeronautical Company in San Diego in the 1920s, where he helped build the *Spirit of St. Louis* for Charles Lindbergh. In 1930 he introduced the now world-famous pilot and his new wife, Anne Morrow, to sailplanes.

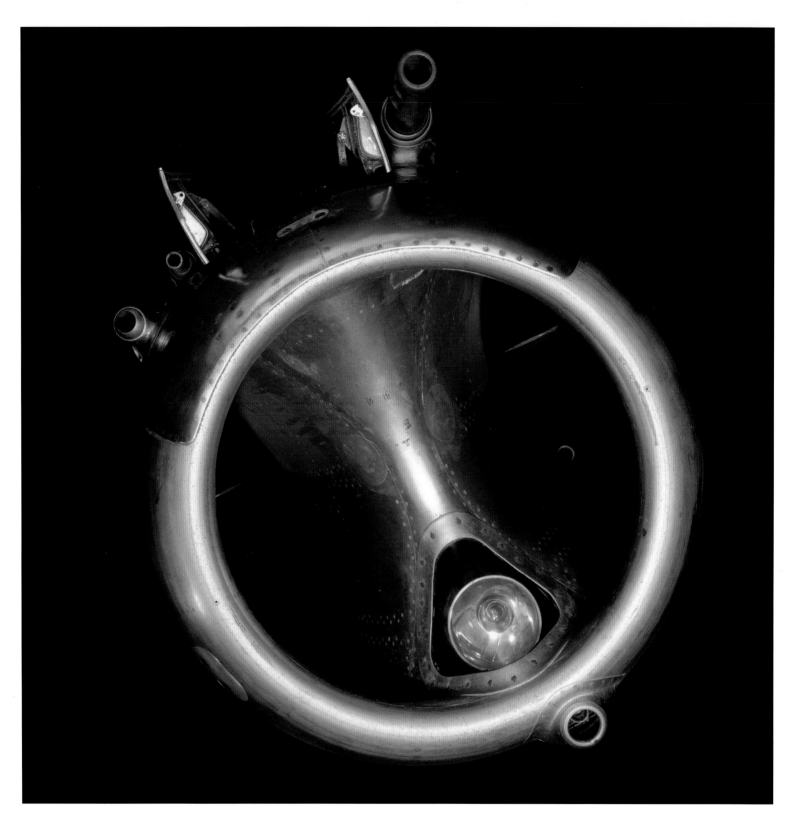

Mikoyan-Gurevich MiG-15 "Fagot B"

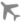

>>Engine Inlet and Landing Taxi Light

This front view of the single-engine jet aircraft shows the divided air intake, the landing taxi light, and the three cannons.

"Shock and awe" aptly describes the reaction of American pilots when MiG-15s began showing up in the skies over Korea in late 1950. The cannon-armed, swept-wing Soviet fighter jet quickly gained dominance over all World War II-vintage piston-engine fighters and bombers and outclassed the first generation of U.S. jets that challenged it. The word "MiG" soon became synonymous with "Soviet fighter." The design was Russian, except for the engine, which was copied from British Rolls-Royce Nene jet engines sold to Russia and then further refined. The MiG-15 was the first production Russian aircraft with a swept wing, pressurized cockpit, and ejection seat. Ultimately, some 35 nations flew the high-altitude interceptor in its many versions.

Although high-flying, fast, and maneuverable, the MiG-15 proved to be an unstable gun platform, and its instrumentation was primitive and cumbersome. The United States countered the Soviet jet with its own: the North American F-86 Sabre.

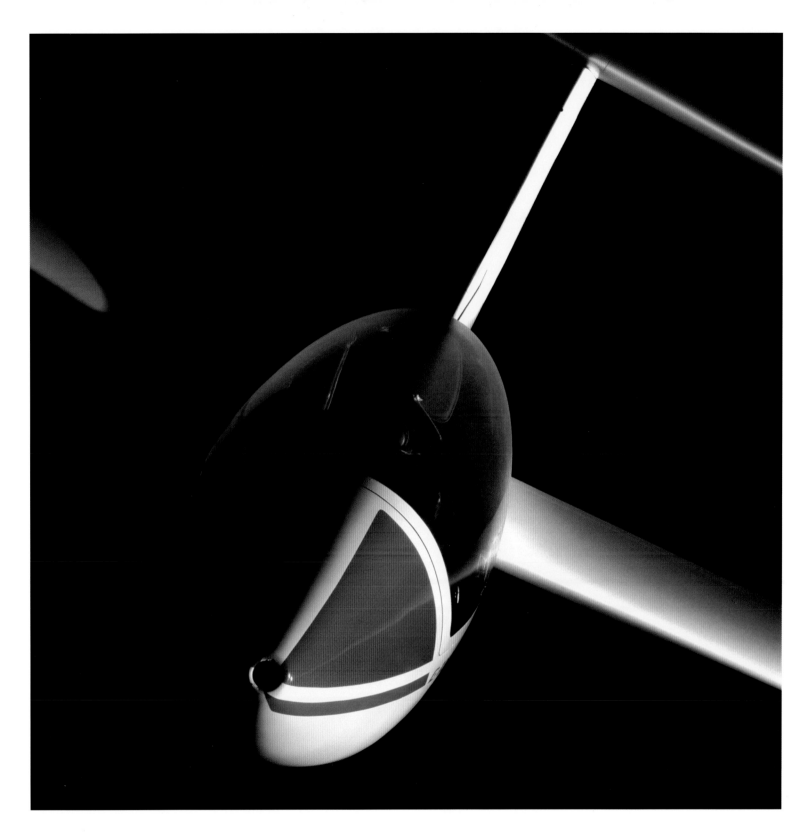

Grob 102 Standard Astir III

>>Canopy

The Plexiglas canopy is integrated into the fiberglass-reinforced plastic fuselage for the purpose of creating the least amount of form drag.

The Grob-Werke company of Germany introduced the Standard Astir III sailplane in the early 1980s to compete in the Standard Class competition category, a class created to promote relatively inexpensive sailplanes. In the hands of pilot Robert Harris, the National Air and Space Museum's Grob 102 broke the world altitude record for sailplanes that had stood for a quarter century.

The old record of 46,267 feet—thousands of feet higher than the cruising altitude of a jetliner—was set by Paul Bickle in 1961. To break the record, Harris spent five years ascending ever higher on the updrafts in the Sierra Nevada mountains of California, first to 20,000 feet, then 35,000, 38,000, and 40,000. Finally, on February 17, 1986, a tow plane hauled Harris aloft in his Astir III and released him for the record attempt.

He worked his way up to 38,000 feet, then caught strong lift that pushed him up at 600 to 800 feet per minute. Frost began to glaze his cockpit, his eyes began to water, and his teardrops froze. Temperatures within the cockpit fell to -65 to -70 °F. His oxygen system began to fail, forcing Harris to break off at 49,009 feet and descend using backup oxygen, but he had exceeded Bickle's altitude record by more than 2,700 feet.

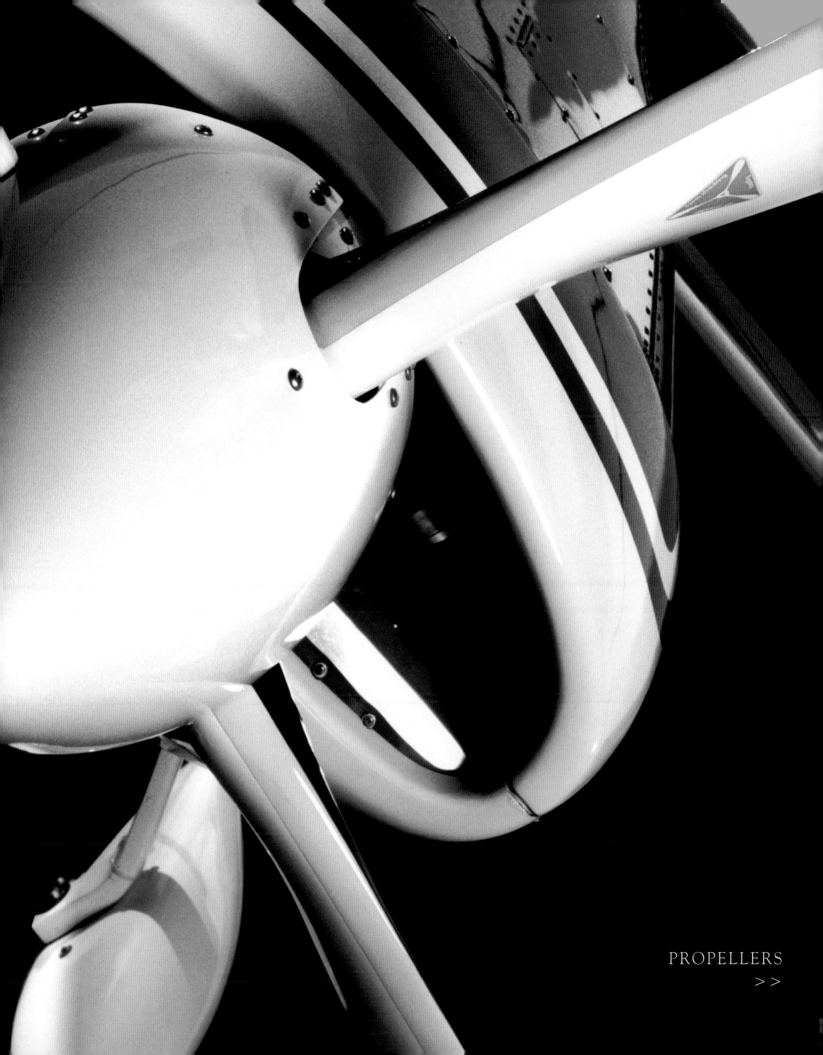

PROPELLERS
>>

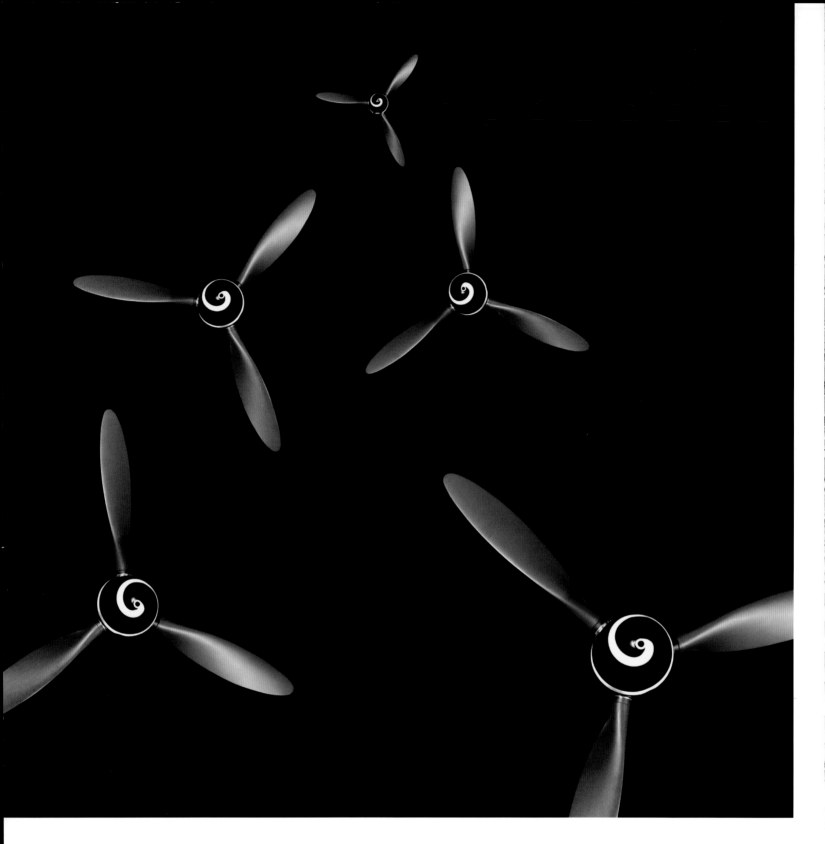

Focke-Wulf Fw 190 F

> *"Painting has come to an end. Who can do anything better than this propeller? Can you?"*
>
> —*Marcel Duchamp*

A subject of fascination to artists since the early twentieth century, the propeller represents both an elegant form as well as providing the mechanical power that lifts aircraft and helicopters into the sky. In this series of photographs, Carolyn Russo tips her hat to machine-age artists of the 1920s and 30s. Her close-up depiction of the Northrop Gamma *Polar Star*'s propeller hub, which captures the aesthetic appeal of its rounded, almost flower-like shape, is reminiscent of the work of Paul Strand or Charles Sheeler. The repetition of the propeller of the Focke-Wulf Fw 190 F evokes Marcel Duchamp's propeller-like kinetic sculpture *Rotary Demisphere (Precision Optics)*.

In other images, Russo uses color and form to convey the power and dynamism of the spinning form. Patty Wagstaff's Extra 260 airplane seems to zoom at us, its colorful propeller foregrounded in front of the blue machine. The boldly positioned, bright yellow Northrop N-1M Flying Wing, with its name clearly visible, quite literally abstracts flying to the aerodynamic form of the propeller-driven wing.

Russo also finds links between the propeller and the natural world. Her depiction of the color and curves of the cowling and propeller of the Grumman F8F-2 Bearcat *Conquest 1* suggests the rising sun. In a more conceptual and poetic transformation, the blades of the Kellet XO-60 become long spindly forms reminiscent of another kind of blade—blades of grass.

speaking to the artist Constantin Brancusi at an air show before World War I

>>*Propeller*

The spiral pattern on the spinner looked like a turning screw as the engine idled. The painted spiral allowed for the ground crew to see that the prop was in motion.

Considered by many to be Germany's best fighter aircraft and one of the best fighters of World War II, the Focke-Wulf Fw 190 served throughout most of the war and on all European and Mediterranean fronts. The Germans nicknamed it the Würger—Butcher Bird—perhaps to spook its opposition, but the aircraft certainly lived up to the name.

For a year after it entered combat in 1941, the Focke-Wulf had no equal. In the seesawing competition between the Allies and Germany to gain the edge in fighter performance, dozens of variants were introduced. Armed with cannons, bombs, rockets, and even torpedoes, Fw 190s served both as fighters and as fighter-bombers. They scoured the daylight skies in search of American bombers and inflicted heavy losses on them. Some served as night fighters. In all, around 20,000 were produced, but even with those numbers they ultimately could not fend off the Allied juggernaut closing in from east and west.

The Fw 190 was technologically significant in several ways. It was Germany's only single-seat fighter powered by a radial engine, and it was the only World War II fighter equipped with electrically operated landing gear and flaps.

Langley Aerodrome A

>>*Propeller Blade*

Two large twin-bladed propellers pushed air toward the rear as they spun. The flat wood and fabric blades, an unsuccessful design, look more like blades of a windmill than propellers.

While the Wright brothers were building and testing gliders and working toward creating a piloted, powered flying machine, another American inventor was closing in on that same goal. Samuel Pierpont Langley, esteemed scientist and secretary of the Smithsonian Institution, had experimented with aerodynamics for years and by 1891 had decided to put his theoretical research to the test.

His designs and approach differed completely from those of the Wrights. Rather than experimenting first with kites and gliders, he built and tested a series of powered, tandem-winged aircraft he called aerodromes, and in 1896 two of his unmanned craft successfully flew. Langley's design for a full-scale, piloted aerodrome would simply be a scaled-up version of his unmanned design.

After successfully flying a quarter-scale model, Langley built his masterpiece, optimistically designated Aerodrome A. It was a sight to behold: a huge craft with a wingspan and length of about 50 feet, with an impressively light and powerful engine and two big pusher propellers. But it proved so structurally unsound and unairworthy that, on two attempts to launch it by catapult from a houseboat, it merely plunged into the Potomac River. A week after his second attempt, the 1903 Wright Flyer flew. There would be no Aerodrome B.

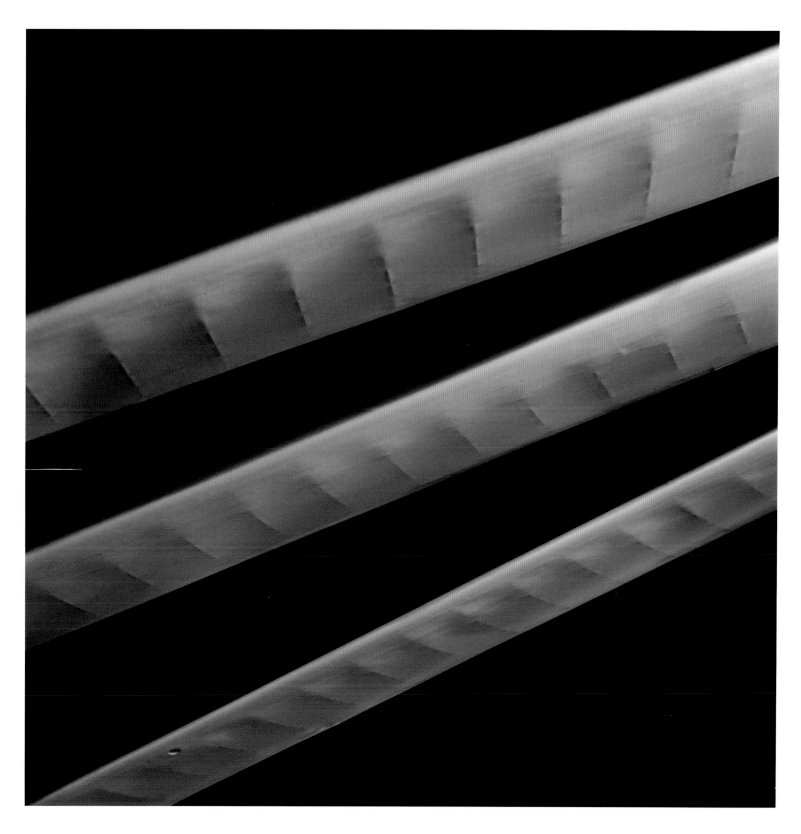

Kellet XO-60

>>Rotor Blades

The rotor blade structure consists of a steel spar crossed by numerous short plywood ribs, all covered tightly with fabric. The Autogiro's blades could fold back for hangar storage.

The Kellet XO-60 marked the end of the line in the United States for the gyroplanes known as Autogiros. It was among the final group of Autogiros ordered for testing by the Army Air Forces during World War II from Kellet and Pitcairn, the two U.S. manufacturers of gyroplanes. All proved inadequate compared to existing aircraft, and Sikorsky helicopters were already operating capably in the field.

The ascendancy of the helicopter had not been a foregone conclusion. The Autogiro was mechanically simpler—its rotor was unpowered and merely spun like a windmill once the aircraft achieved forward motion using a conventional propeller. It could fly slowly and take off and land in confined areas. Another Autogiro could fold back its wings and drive off down the road. Later versions, such as the XO-60, could perform a "jump takeoff," in which the pilot spun

the rotor up to speed before takeoff, enabling the aircraft to leap almost vertically into the air. But what an Autogiro could not do was hover.

The Army Air Forces gave Kellet and Pitcairn a sporting chance to prove the technology. But with limited funding and frequent accidents, the Autogiro's fate was sealed. Rolled out in 1944, the XO-60 was the last of the Cierva-type Autogiros built.

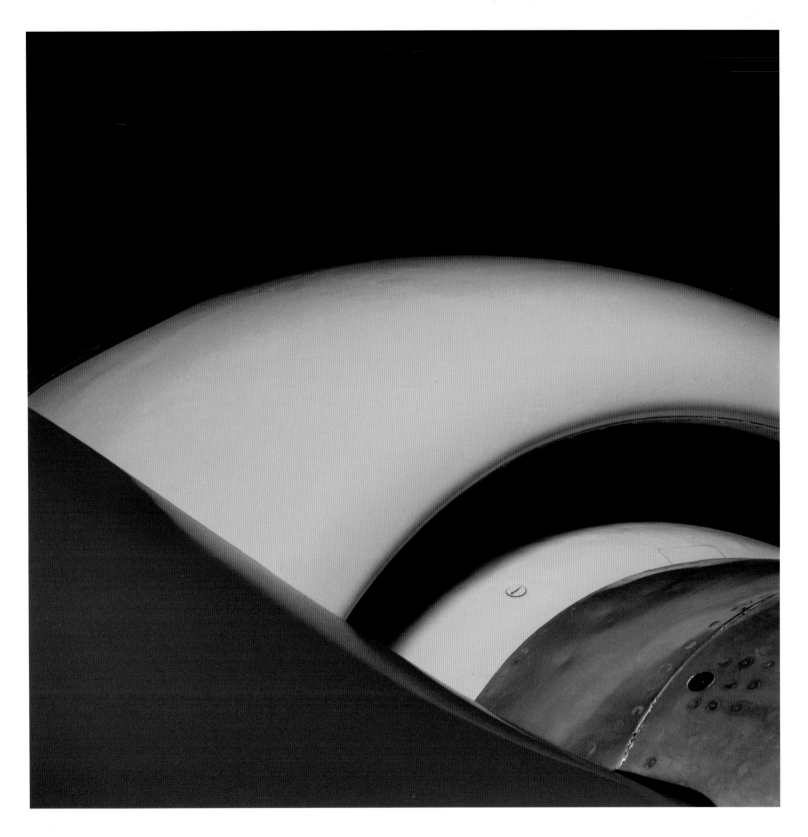

Grumman F8F-2 Bearcat
Conquest 1

>>Cowling and Propeller

The cowling is the same vivid yellow as the
rest of this racing airplane. To allow the big
four-bladed prop to clear the ground, the
Bearcat had to have tall main retractable
landing gear.

In 1939 a new German airplane expressly designed to break speed records, the Messerschmitt Me 209, set a world speed record of nearly 470 miles per hour. That record for propeller-driven airplanes would stand for 30 years, until Darryl Greenamyer topped it in his Bearcat *Conquest 1*.

Grumman developed the Bearcat late in World War II to replace the Navy's aging Hellcat fighter. The Bearcat flown by Greenamyer, an air racer and former Lockheed test pilot, bore only a superficial resemblance to the original design. He shortened the wings and added a big four-bladed propeller from a Douglas A-1 Skyraider and a spinner from a North American P-51 Mustang. He installed a tiny canopy that allowed him barely enough room to turn his head. He sealed surface gaps with putty to reduce drag. To shave weight, he elimi-nated the electrical system, most of the hydraulic system, and all other unnecessary components. He fed the 3,100-horsepower Pratt & Whitney R-2800 special high-octane fuel.

Greenamyer flew *Conquest 1* to six victories in the National Air Races, and in 1969 he finally smashed the 30-year-old record by flying the Bearcat 483 miles per hour.

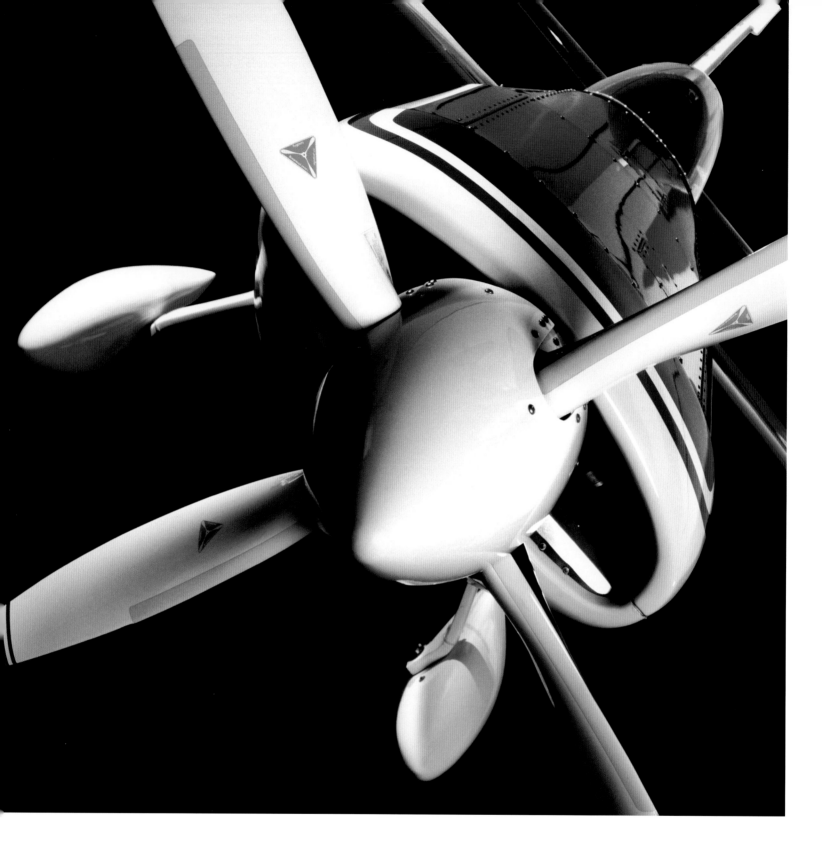

Extra 260

"It's all about the prop and the engine overcoming the weight of the aircraft…even bathtubs can fly with enough HP (horse power)!"

—*Patty Wagstaff*
U.S. National Aerobatic Champion 1991–1993

from a conversation with Dorothy Cochrane
(Curator at the National Air and Space
Museum), 2006

>>*Propeller*

The four-bladed MT natural composite
propeller is designed for extreme aerobatics.
This lightweight Unlimited Class propeller
reduces drag and vibration and thus increases
overall engine performance. The aircraft's
beautiful streamlining was designed for speed.

A one-of-a-kind creation of German
designer Walter Extra, the Extra 260 flew
to unlimited aerobatic competition glory
in the 1990s piloted by Patty Wagstaff. In
1991 in the Extra 260, Wagstaff became
the U.S. National Aerobatic Champion—
the first time a woman had captured
the title since the men's and women's
aerobatic competition were merged 12
years earlier. Wagstaff repeated in the
260 the following year, then retired the

airplane and switched to Extra's newest
model, the 300S. With it she won the
1993 championship, her third in a row.

The Extra 260 was a blend of the
traditional and the high-tech. It had a
conventional steel-tube fuselage and fully
symmetrical wooden wings covered with
fabric, but the tail surfaces and landing
gear were modern composite materials,
and it had an almost full-length carbon-
fiber aileron. The monoplane's wing was

designed to make the 260 laterally
unstable, increasing its maneuverability
and making it quicker to respond to the
pilot's touch. Sighting devices on each
wingtip aided in precision maneuvering.

A strong, light aircraft with ex-
traordinary performance and handling,
the Extra 260 could roll at the rate of
360 degrees per second and climb straight
up at 4,000 feet per minute. In the hands
of Patty Wagstaff, it proved unbeatable.

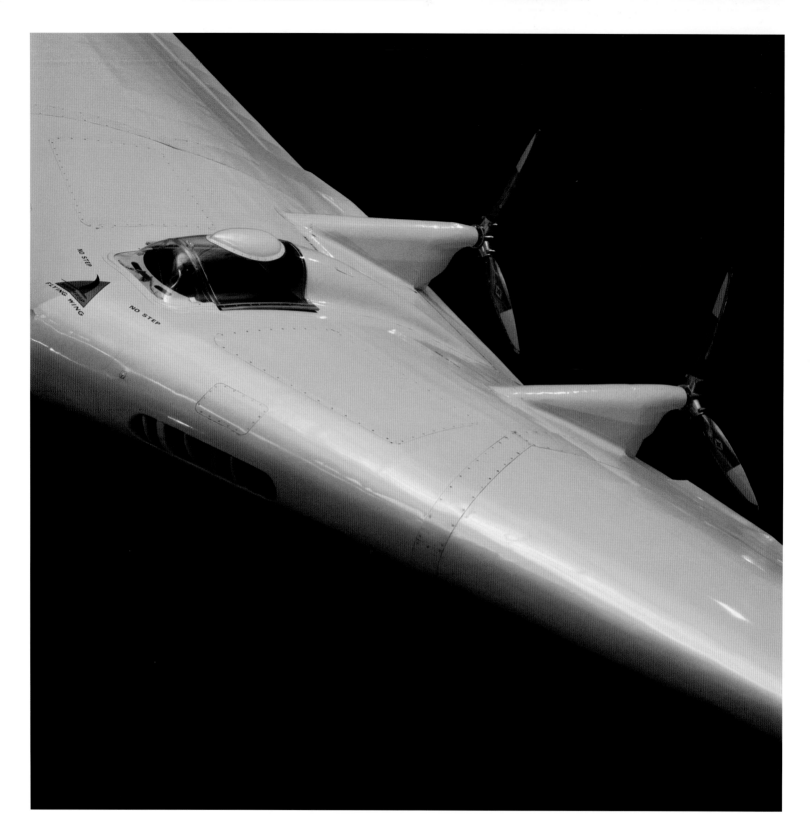

Northrop N-1M

>>Dual "Pusher" Propellers

Mounted in the rear of the aircraft, the propeller blades push, rather than pull. Unusual in their construction, they are made of laminated wood carved into the correct shape, then smoothly finished. Their painted tips trace a yellow ring while spinning.

While still in the biplane era, legendary aircraft designer John K. "Jack" Northrop was already working toward creating the ultimate aerodynamically clean design, one without engine nacelles, fuselage, or tail surfaces.

Northrop created his first flying wing in 1929, an innovative all-metal, multicellular wing with stressed-skin construction. But it still had external control surfaces and outrigger tail booms and was difficult to fly. Lacking funds, he set aside the idea and went on

to develop more conventional designs that incorporated some of the pioneering features of his flying wing. A decade later he resumed his experimenting, and in 1940 he rolled out the N-1M, the first true flying wing. The yellow boomerang-shaped craft was made of wood and tubular steel, had control surfaces built into the wing, and was powered by two pusher propellers.

Its first flight was accidental; the N-1M bounced into the air during a high-speed taxi

run and stayed up for a few hundred yards. Overweight and underpowered, it never performed well, but it proved the flying wing concept was sound. Northrop developed large prototype flying wings for the Army Air Forces after World War II, but the project proved short-lived. Four decades later, however, the B-2 stealth bomber appeared in the sky, the belated fulfillment of Jack Northrop's dream.

The N-1M is one of only two surviving Northrop flying wings.

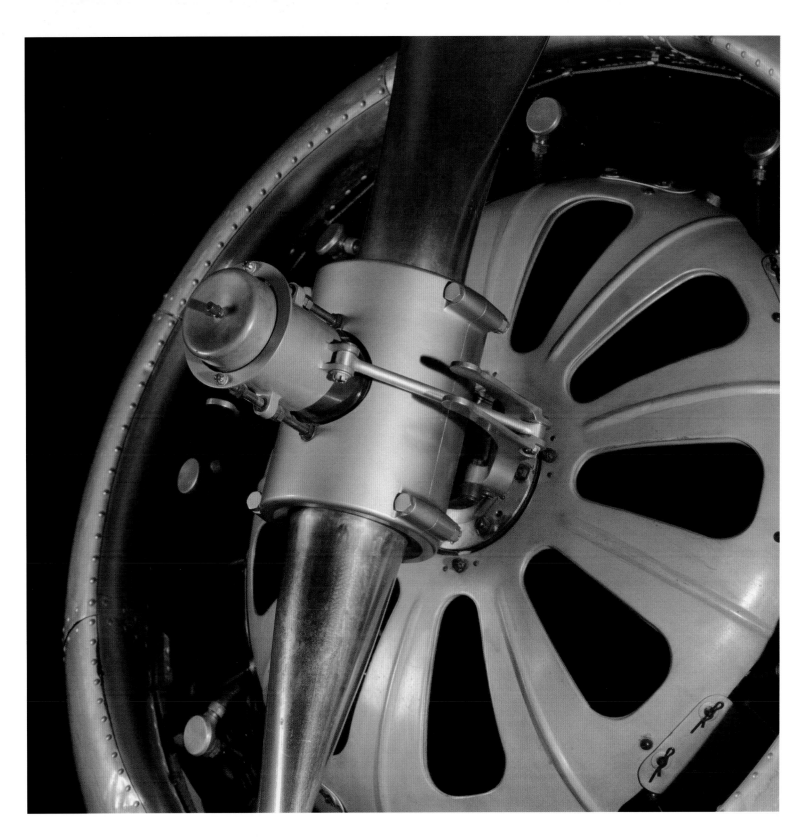

Northrop Gamma
Polar Star

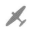

>>Variable-Pitch Propeller

The angle of the blades can be changed from the cockpit to maximize their efficiency during high- and low-speed flight. The piston protruding in the center slides in and out, moving gears inside the hub that rotate both blades.

Among the Greek-letter series of early designs produced by Northrop companies (of which there were several), the Gamma became the best known, mainly because of its use in exploration and record setting.

Although configured in different ways, the all-metal Alpha, Beta, Gamma, and Delta shared many of the same design features: wing fillets (fairings between the wing and fuselage to improve air flow), multicellular stressed-skin wings, and fixed landing gear enclosed by aerodynamic spats, which made the aircraft look like they were wearing chunky winter boots but helped reduce drag. The Alpha and Beta had open cockpits (and the Alpha an enclosed cabin); the Gamma and Delta were fully enclosed. These transitional designs led to such aircraft as the famous Douglas DC-3 airliner.

The *Polar Star* became famous for its Antarctic exploits. Explorer Lincoln Ellsworth took the airplane to the largely unexplored continent several times in the hope of becoming the first to cross it by air. After several aborted attempts, he finally made the crossing with pilot Herbert Hollick-Kenyon in November 1935, but the 2,400-mile flight ended up taking a harrowing four days, plus six days of walking after they ran out of gas. They were the first to visit western Antarctica.

GRAPHICS
>>

Hawker Hurricane Mk. IIC

"The relationship between the object and the event. Can they...be separated? Is one a detail of the other? What is the meeting? Air?"

—*Jasper Johns*
Artist

From the very beginning of their history, planes have been painted with eye-popping designs intended to attract attention, distract enemies, or to celebrate the feats of pilots. These photographs celebrate the artistry of airplanes and spaceships, whose embellishments become the inspiration for photographic compositions that resemble the geometric abstractions of Ellsworth Kelly and Morris Louis and the pop art of Jasper Johns and Robert Indiana.

Through Carolyn Russo's lens the patriotic inclusion of the stars and stripes on Gemini IV space capsule becomes an artistic statement. A black and yellow composition on the Albatros D.Va recalls the vivid markings of a street sign, while even the "F" on the Farman F.60 and the stark black and white lettering on Wiley Post's Lockheed Vega *Winnie Mae* becomes a study in shapes and lines. The stars that adorn SpaceShipOne merge in Russo's photographic composition with the circles of its windows and the curve of its entry hatch to create a whimsical design.

The playful question mark that bedecks the North American P-51D Mustang *Willit Run?* evokes larger questions about the mechanics and potential of flight—or even human experience itself.

from *Sketchbook Notes*, 1960

>>Roundel

The roundel appears on both sides of the fuselage and wings. The emblazoned marking easily identified the aircraft as belonging to the Royal Air Force.

"Never in the field of human conflict was so much owed by so many to so few," spoke Winston Churchill in August 1940; he was speaking about the perilously outnumbered force of Hurricane, Spitfire, and other pilots defending against the Luftwaffe during the Battle of Britain. The Royal Air Force (RAF) lost more than 900 airplanes and 400 pilots in four months, but it prevented a German invasion of Great Britain.

The revolutionary Hurricane was already a glimmer in the mind's eye of Hawker chief designer Sydney Camm in 1925, a time when "airplane" generally meant "biplane." Camm envisioned an aerodynamic, single-wing fighter that would be faster than and far superior to biplane fighters. His Hurricane would become Britain's first monoplane fighter and its first fighter to break 300 miles per hour in level flight.

It took 10 years before Camm's concept literally took flight, and with another war with Germany looming, it was none too soon. The RAF ordered 600 Hurricanes before prototype testing was even finished. By late 1944, when production ended, more than 14,000 Hurricanes of numerous versions had been produced. Long after the Battle of Britain had been won, Hurricanes continued to serve throughout Europe and around the world.

De Havilland Canada DHC-1A Chipmunk Pennzoil Special

>>Wing

The longer aileron on a shorter wing improved roll performance during aerobatic maneuvers. The wing's American flag-style paint scheme was the aircraft's identifying signature.

De Havilland developed the Chipmunk to replace its Tiger Moth trainer, which British air forces used throughout World War II. The company's Canadian subsidiary designed the aircraft; thus its woodsy name, which nicely complemented those of de Havilland Canada's Beaver, Otter, and Caribou.

After the prototype first took wing in 1946, Chipmunks were produced both in Canada and England into the 1950s. The aircraft was a conventional low-wing, single-engine, tandem two-place trainer. But aerobatic performer, racer, and movie pilot Art Scholl saw greater potential in the Chipmunk. He bought two and heavily modified the second, the *Pennzoil Special*, for his aerodynamically demanding line of work. He flew it at air shows throughout the 1970s and early 80s.

In fact, Scholl so heavily modified the *Penzoil Special* that it was practically a new design, with a single-place cockpit, new engine, modified wings and airfoil, larger vertical fin and rudder, and more. He installed smoke generators that produced trails of red, white, and blue smoke. Scholl often flew with his dog Aileron, who would sit on his shoulder or ride the wing as they taxied down the runway. Scholl was killed in 1985 while flying a Pitts Special during filming for the movie *Top Gun*.

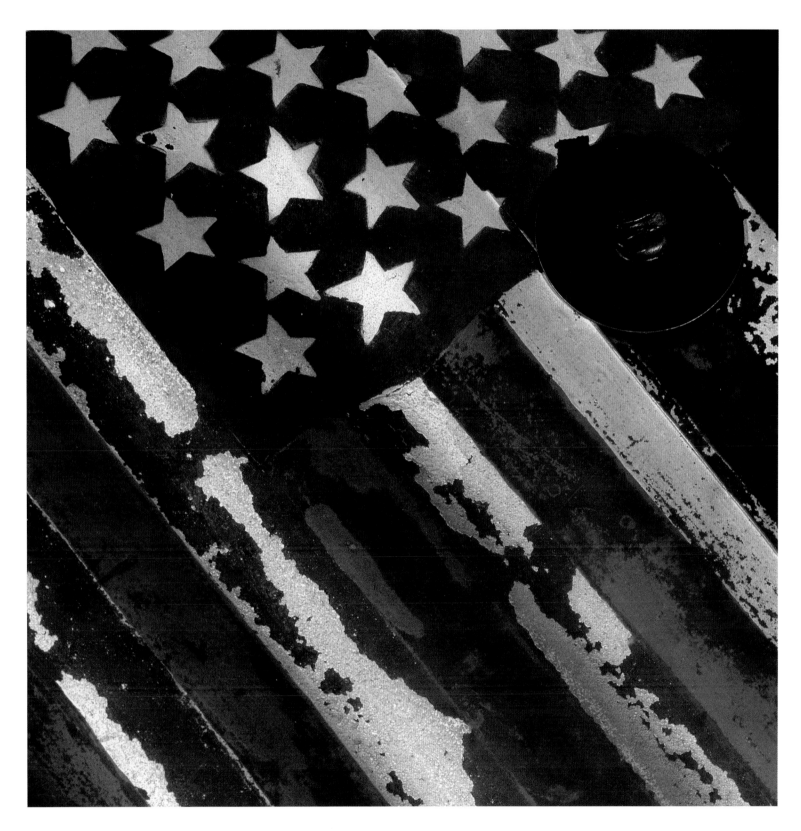

Gemini IV

>>Capsule Surface

The standard marking for all American manned spacecraft is an American flag. This small flag painted on the side of the capsule survived the rigors of reentry.

For several years, the Soviet Union always seemed one step ahead of the United States in the Space Race. In early 1965, for example, cosmonaut Aleksei Leonov became the first human to leave his spacecraft and enter space. Three months later on June 3, Gemini IV astronaut Edward H. White became the first American to perform a "spacewalk," or Extra Vehicular Activity (EVA) in NASA jargon.

Gemini IV orbited the Earth 66 times over four days, during which White and fellow astronaut James A. McDivitt photographed the world below, took space radiation measurements, studied the effects of weightlessness, and attempted, unsuccessfully, to rendezvous with the second stage of their Titan II launch vehicle. But the 20 minutes or so White spent in space—about 10 minutes longer than Leonov, by the way—made

the Gemini IV mission historic.

After decompressing the spacecraft, White climbed out of the hatch into the airless void. He remained connected to the capsule's life-support and communications systems by a long "umbilical cord" and used a hand-held jet thruster to move about in space. White's walk was a short one, but an important stroll nonetheless toward the lengthy EVAs that Apollo and Space Shuttle astronauts would someday perform.

SpaceShipOne

"For my part I know nothing with any certainty, but the sight of the stars makes me dream."

—*Vincent Van Gogh*

from *Great Aviation Quotes*, 2007

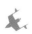

>>*Windows and Stars*

Many circular windows are used in SpaceShipOne's innovative design. The air pressure stresses on multiple smaller windows are less than on a single long windshield. The thin curved line marks the circular cockpit hatch.

Commercial space travel came one step closer to reality on June 21, 2004, when SpaceShipOne fired up its rocket, ascended to an altitude of 100 kilometers, then glided back to Earth, a 24-minute flight that made it the first privately developed, piloted vehicle to reach space. SpaceShipOne repeated that feat two more times in the following months, reaching 102 and 112 kilometers, thus winning the $10 million Ansari X Prize for repeated suborbital flights in a privately developed spacecraft.

Aeronautical engineering wizard Burt Rutan designed SpaceShipOne, backed by the co-founder of Microsoft and philanthropist Paul G. Allen. Mike Melvill and Brian Binnie piloted it on its record-setting flights. Although they flew solo, SpaceShipOne can carry two passengers. Its unique design features a lightweight composite structure with twin swept wing-tail booms, which pivot upward in space to help stabilize and slow the craft for reentry, and a hybrid ascent rocket that burns both liquid and solid propellants. Another unique craft, the Rutan-designed White Knight mothership, carried SpaceShipOne aloft.

With SpaceShipOne, private enterprise entered the realm of human spaceflight, where only governments had gone before. The robust little vehicle showed that civilian space travel and even space tourism might someday be within reach.

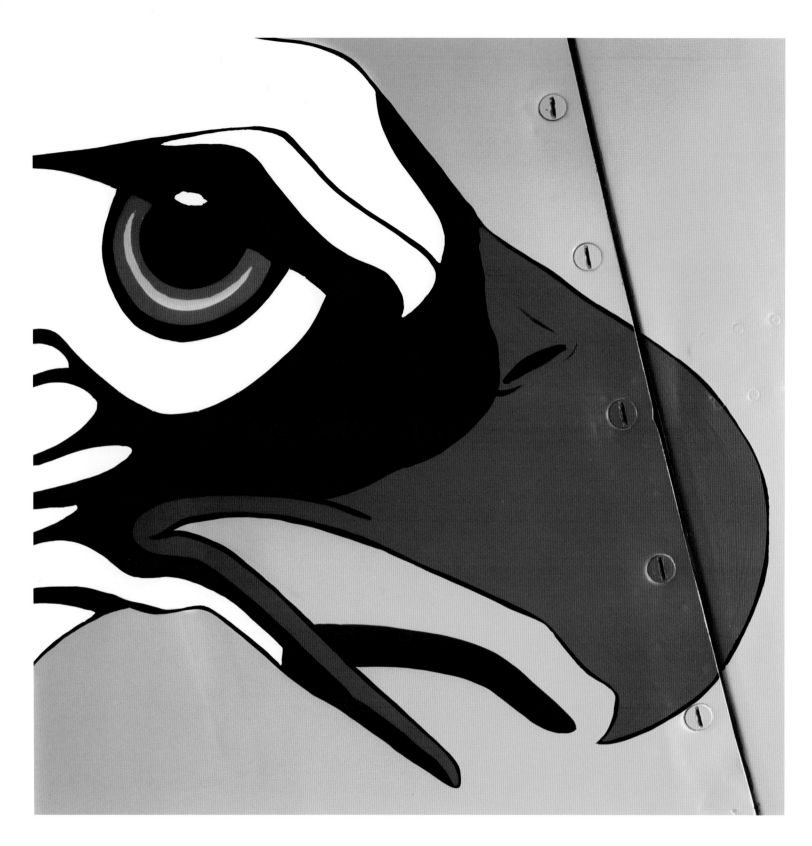

Grumman F8F-2 Bearcat
Conquest 1

>>Engine Cowling

This racing plane with its eagle paint scheme
was entertaining for air show spectators;
however, the pilot endured extreme heat
conditions in the cockpit from exhaust leaks
located beneath the cowling. An icepack was
used to cool off the pilot's hands while flying.

>>*Retractable Landing Gear*

Completely modified for air racing, the hydraulic landing gear system on this WWII plane was replaced with a lighter 1-shot nitrogen system. A small nitrogen bottle was used to retract the gear while gravity was the force that lowered it.

>>see **P.72-73** for more.

Lockheed F-104A Starfighter

>>*Nose Section*

The long and sleek nose was ideally shaped
to easily pass through the sound barrier and
to accommodate the shock waves.

>>see P.40-41 for more.

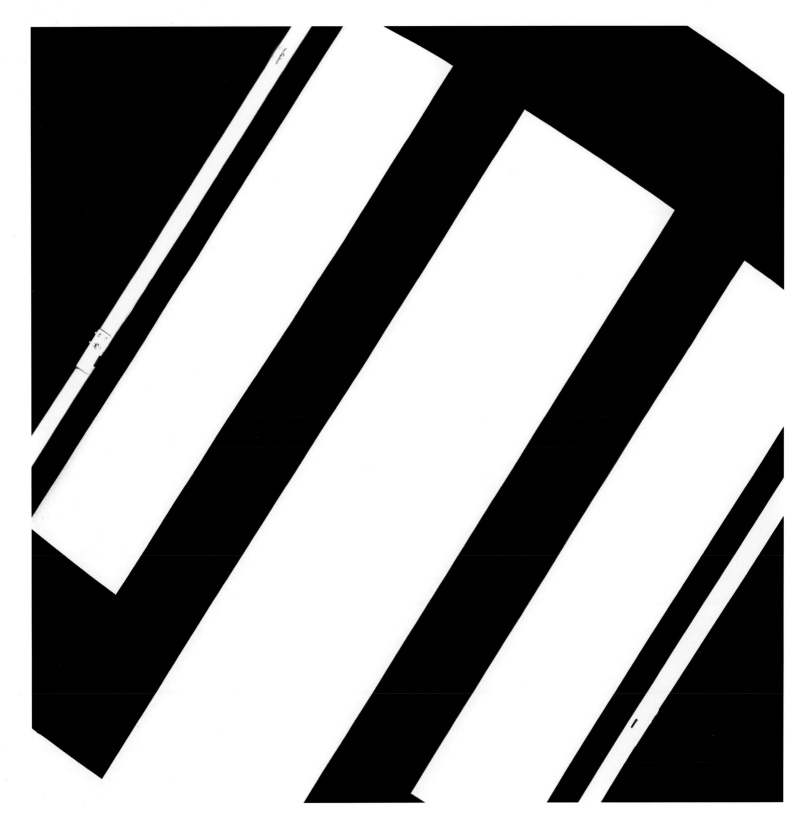

Vanguard Launch Vehicle

>>*Launch Vehicle Exterior*

These painted markings, usually called a roll pattern, assisted ground crews with tracking the vehicle. The markings helped them determine the orientation and location of the vehicle while in flight.

In the 1950s, scientists planned a worldwide, year-long effort to study the Earth in 1957–58 called the International Geophysical Year. As a part of this endeavor, both the United States and the Soviet Union announced intentions to place an artificial satellite in orbit. The U.S.S.R. succeeded first, sending Sputnik into space in October 1957, and then a second, larger Sputnik the following month.

The U.S. Navy was in charge of the American effort. Their launch vehicle of choice was the Vanguard, a research rocket descended from the Navy's Viking and Aerobee sounding rockets. Their first attempt to launch a satellite, in December 1957, was an embarrassing failure; the rocket self-destructed on the launch pad. The U.S. Army Ballistic Missile Agency and the Jet Propulsion Laboratory made the next attempt, and they successfully launched Explorer I on January 31, 1958,

using a Jupiter-C missile.

The Navy kept trying, but their second launch attempt also proved disastrous. Finally, on March 17, 1958, a Vanguard launch vehicle succeeded in placing the nation's second satellite in orbit: Vanguard 1. Several more unsuccessful Vanguard launch attempts followed, but Vanguard satellites 2 and 3 eventually made it into space. A half-century later, Vanguard 1 remains the oldest satellite in orbit.

Bücker Bü-133 C
Jungmeister

>>Landing Gear

The split-axle undercarriage has oil-damped shock absorbers like the front forks of a motorcycle. The long legs give the Jungmeister its stalky appearance when airborne.

German aircraft designer Carl Bücker based his single-seat Jungmeister biplane on his two-seat Bü-131 A Jungmann, a popular trainer for sport pilots during the 1930s. Germany had been forced to disband its air force after World War I, so the Jungmann also helped train pilots for a clandestine air arm that would soon emerge as the Luftwaffe.

With a high power-to-weight ratio, ailerons on both upper and lower wings, and distinctively swept-back outer wing panels, the light and agile Jungmeiser proved to be a winning aerobatic aircraft. A favorite of European flying clubs, it dominated aerobatic competitions in Europe and the United States from the mid-1930s through the 1940s. Only a few were produced after World War II.

The National Air and Space Museum's Jungmeister has a notable—and tragic—history. Four great aerobatic pilots flew it. Romanian Alex Papana brought it to America crated aboard the airship *Hindenburg*, and both he and rival Count Hagenburg (who borrowed it after his own plane crashed) flew it during the 1937 Cleveland Air Races. Mike Murphy won the 1938 and '40 American Aerobatic Championships in it, and Beverly "Bevo" Howard the '46 and '47 titles. Howard died in a crash in the airplane in 1971.

Republic P-47D Thunderbolt

>>*Engine Cowling*

Many military squadrons painted unique and colorful designs on their aircraft to distinguish their units from one another.

Along with the P-51 Mustang and P-38 Lightning, the P-47 Thunderbolt ranked as one of the best fighter aircraft flown by the U.S. Army Air Forces during World War II. The United States built over 15,000 P-47s, more than any other American fighter.

The Thunderbolt was the largest and heaviest single-engine, propeller-driven fighter ever built and, with its eight .50 caliber machine guns, the most heavily armed fighter yet built. Republic designed it around the biggest, most powerful engine available, the 2,000-horsepower Pratt & Whitney R-2800 radial. The massive airplane felt cumbersome—it was more than twice as heavy as a British Spitfire. Pilots nicknamed it the Jug, which pretty well described the airplane's shape.

The Jug may not have been as nimble as a Spitfire or Hurricane, but it could dive like a bucket of cement dropped from the sky, and it could absorb a legendary amount of punishment and still keep flying. Although designed as a high-altitude interceptor, it also served as a bomber escort and became an incomparable ground-attack weapon.

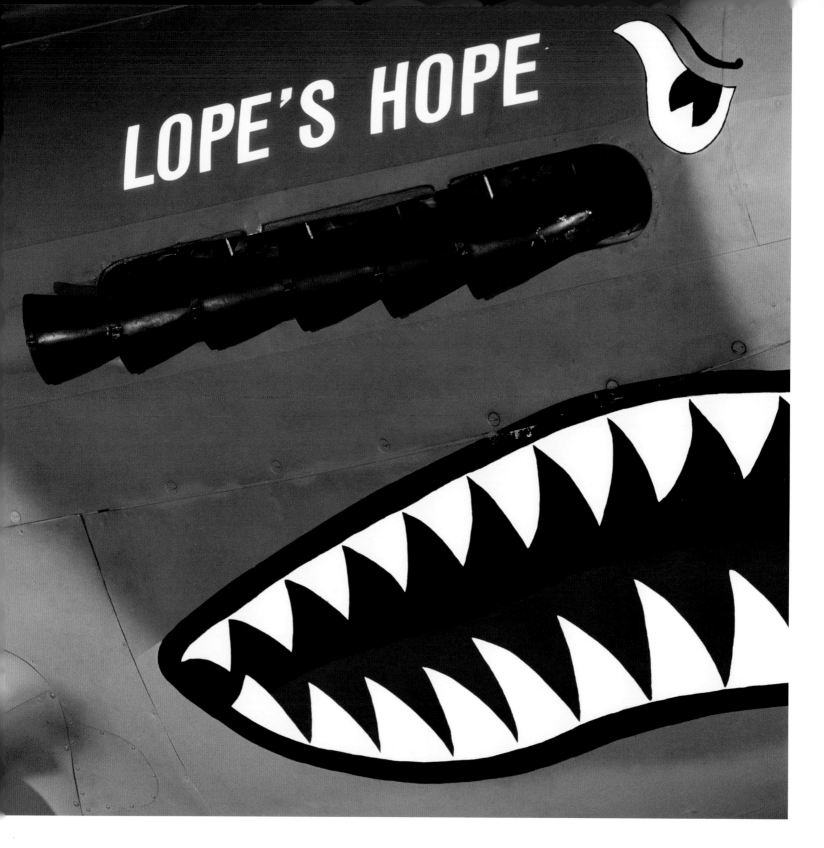

Curtiss P-40E Kittyhawk

"*Naming one's airplane was serious business. I'm sure we put at least as much thought into it as we put into naming a first child…. I racked my brain, since this was one of the few decisions a lieutenant was permitted to make.*

Although I wasn't too happy with it, I had about decided on 'Pistol Packin' Mama,' after a popular song, when Sack Folmar suggested 'Lope's Hope'—an inspired name, I must say.

It was just what I was searching for: a short, distinctive name immediately associated with me."

Don Lopez
Deputy Director of the National Air and Space Museum

from *Into the Teeth of the Tiger*, 1997

>>*Forward Fuselage*

The name *Lope's Hope* is in recognition of the National Air and Space Museum's Deputy Director, Donald S. Lopez, who flew with the 23rd Fighter Group of the 14th Air Force in 1943. Although this aircraft did not serve in the U.S. military, it was restored in 1975 and painted to resemble his aircraft.

>>see **P.61** for more.

North American Rockwell
Shrike Commander 500S

>>*Rudder and Left Stabilizer*

The dark covering on the rudder is a deicing boot. If ice forms on the boot, air pressure expands and breaks off the ice.

Robert A. "Bob" Hoover proved that even a stock business aircraft could be a hoot to fly. The legendary test pilot, combat veteran, and aerobatic flyer acquired a seven-year-old Shrike Commander in 1979 and did things with it that no business aviator would ever dare.

Introduced in 1958, the Aero Commander 500U, later renamed the Shrike, was a high-wing, pressurized, four-place aircraft powered by two turbo-supercharged piston engines—an appealing, workmanlike craft for business flyers but not exactly the stuff most aerobatic pilots dream about. Hoover, however, not only got his kicks flying a snappy P-51 Mustang at air shows around the United States and the world, but he also enjoyed demonstrating the capabilities of more mundane aircraft such as the Shrike, which in fact proved more challenging than his fighter plane.

Hoover's routine with the aircraft included demonstrating high- and low-speed handling capabilities, one-engine performance, loops and rolls, and deadstick (no-engine) maneuvers and landings. In one superbly skillful stunt captured on film, Hoover completely rolled the Shrike Commander with one hand, while using the other hand to pour iced tea from a pitcher into a glass set atop his instrument panel. And he didn't spill a drop.

Sukhoi Su-26M

>>*Wing*

The high-performance composite wing can handle the ultimate load of +12 and -10 Gs used in extreme aerobatics. The aircraft is adorned with an elaborate custom paint scheme that masks its Russian origins.

>>see **P.44** for more.

Farman F.60

>>*Rudder*

The rudder was made of wood and covered with fabric, which was then painted. This stylized letter "F" stood for Farman and appears at the top of the rudder.

The French brothers Henri and Maurice Farman enjoyed great success as aircraft manufacturers during the first decades of flight. They had different design philosophies, which they meshed in 1915 to produce the F.40, a reconnaissance aircraft and bomber.

The pusher-engine biplane bore the signature of each: a two-place cockpit suspended between wings of differing spans (Maurice) and a pair of tail booms converging to a point (Henri). Their combined visions, however, did not make the Henri/Maurice design (called a "Horace" by some) a superior aircraft. It turned out to be barely better than the airplanes it replaced, and without the protection of escorts it proved too vulnerable to fighters. F.40s were declared obsolete a year after entering service.

The Farmans produced several variants of the F.40, including a seaplane. Many differed only in their engine type. The rudder pictured here is the only surviving part from an F.60, basically an F.40 equipped with a more powerful 190-horsepower Renault engine. Toward the end of World War I the Farman company produced a completely different aircraft— a big twin-engine bomber—also called an F.60. That F.60 became the widely used Goliath airliner.

Lockheed 5C Vega
Winnie Mae

>>Fuselage

These names represent places Wiley Post stopped during one of the two round-the-world trips he made in the *Winnie Mae*. The names shown here cover part of the route through Siberia, Alaska, and Canada.

The advanced design of the Lockheed Vega made it a favorite of pilots seeking to set aviation records in the 1930s, an era when setting aviation records practically turned into the national pastime. No Vega became more famous than the one flown by renowned air racer and record setter Wiley Post.

Named for owner F. C. Hall's daughter, the *Winnie Mae* first drew attention when Hall allowed Post, his hired pilot, to fly the plane in the 1930 Los Angeles to Chicago Air Derby, part of the National Air Races. Post won the race, then set his sights on the ultimate distance record: a round-the-world flight. With navigator Harold Gatty, Post circled the globe in 1931 in less than nine days. Hall was so impressed, he gave Wiley the *Winnie Mae* as a gift.

Post topped that feat two years later by circling the world alone, while shaving a day off his and Gatty's time. Then he began experimenting with high-altitude flight. He took the unpressurized airplane as high as 50,000 feet while wearing a custom-designed full pressure suit, the first practical one ever developed. On a cross-country flight in 1935, Post reached the jet stream, and the *Winnie Mae* cruised to Cleveland faster than a Vega had ever cruised before.

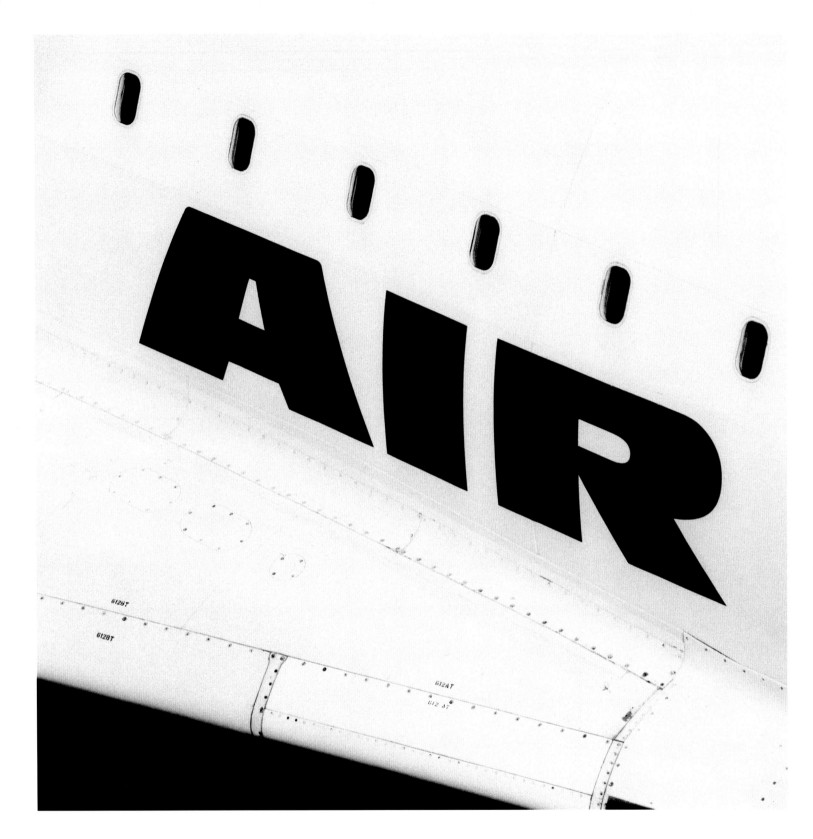

Concorde

>>*Passenger Windows*

The windows were small to withstand the higher air pressure differences when flying at cruise altitude—higher than normal commercial airliners.

The first supersonic airliner, the Concorde flew for 27 years before succumbing to economic realities. While glamorous and prestigious to fly, Concordes were also fabulously expensive to operate. They burned as much fuel as a Boeing 747 but carried only a fourth as many passengers. Tickets cost many thousands of dollars. Their four powerful engines were screamingly loud, restricting where Concordes could land. But if speed was what you wanted, no other airliner came close.

A joint venture by France and Great Britain, the Concorde began flying commercially in 1976. Only 14 entered service, all for Air France and British Airways. The 100-passenger, delta-wing aircraft cruised at 55,000 feet at twice the speed of sound, so fast that when flying from London to New York—less than a four-hour trip—you arrived before you left, at least according to local time. The cabin was snug but comfortable, the ride quiet, the windows small, the view incomparable.

The Concorde, however, proved not to be the airplane of the future. A Soviet-built version fared poorly, and plans for an even faster American supersonic transport wilted on the economic vine because of environmental concerns and lack of airline interest. The short-lived era of commercial supersonic flight ended with the Concorde's retirement in 2003.

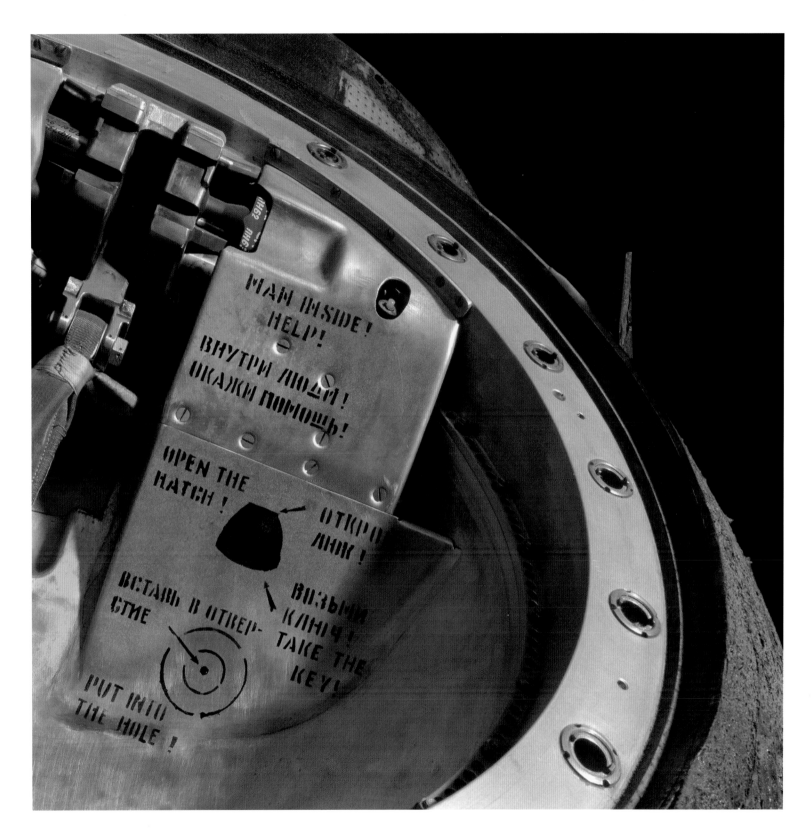

MAN INSIDE!
HELP!

ВНУТРИ ЛЮДИ!
ОКАЖИ ПОМОЩЬ!

OPEN THE
HATCH!

ОТКРО
ЛЮК!

ВСТАВЬ В ОТВЕР-
СТИЕ

ВОЗЬМИ
КЛЮЧ!
TAKE THE
KEY!

PUT INTO
THE HOLE!

Soyuz TM-10 Landing Module

>>*Escape Hatch*

The writing on the escape hatch in both Russian and English provides instructions for the safe exit of the crew once on the ground.

The Soviet/Russian Soyuz has been in use since the 1960s, longer than any other type of manned spacecraft. The three-part modular craft was launched into and flown in Earth orbit; only the landing module returned. Unlike the U.S. Mercury, Gemini, and Apollo spacecraft, which landed in the ocean and were recovered by Navy ships, the Soyuz landed on the ground, usually in Kazakhstan, a former Soviet republic.

Soyuz spacecraft have been upgraded over the years with better electronic and navigation systems and roomier interiors. The original Soyuz held up to three cosmonauts without spacesuits. Later versions, the Soyuz ferry and Soyuz T transport models were designed to carry two or three cosmonauts in spacesuits to the Salyut space station.

The Soyuz TM, or modified transport version, debuted in 1986 and was

designed to service the Mir space station. The particular Soyuz designated TM-10 visited Mir for a four-month stay in 1990. Among its occupants on the spacecraft's return trip was a Japanese journalist, the first of many international guests who had been taken into space aboard Soyuz spacecraft since 1978. The TM-10's charred exterior testifies to the scorching heat generated by its fiery return through the atmosphere.

Pitts Special S-1C Little Stinker

"Bands of purple and violet, cobalt blue and fluid gold shot out from the circle. Dancing like diamonds in the brilliant light, breathtaking ribbons of color permeated our very soul."

—*Betty Skelton*
International Feminine Aerobatic Champion, 1948-1950

from *Little Stinker*, 1977

>>*Wing and Engine Cowling*

The single-piece wing with a racy sunburst paint scheme evoked speed and agility to the spectators and judges watching from the ground. The 6.5-degree sweep to the wing added stability to the tiny aircraft and allowed the pilot to access to the cockpit more easily.

Great things, it is said, come in small packages, and as airplanes go, they don't get much smaller than Pitts Specials. In 1946, when Curtis Pitts built the one that would gain fame as *Little Stinker*, it was the smallest aerobatic airplane in the world. The agile little craft could climb, roll, and change attitude faster than larger aerobatic biplanes, and its distinctive swept wing helped make its snap rolls snappier.

The airplane's most famous owner, Betty Skelton, bought the airplane in 1948, named it *The Little Stinker Too*, and won the 1948 and 1949 International Feminine Aerobatic Championships with it. Then she gave it a flashy red and white color scheme and a skunk decoration, dropped the *Too*, and won the 1950 Championships as well. Had she not retired the next year, she might have kept on winning with it.

Pitts Specials might have had only a fleeting, if important, place in aerobatic history. But in the early 1960s, Pitts began producing construction drawings for a homebuilt version, and the type really took off. Pitts Specials dominated aerobatic competition throughout the 1960s and 70s and became the most successful and recognized American aerobatic design. Many are still snap-rolling today.

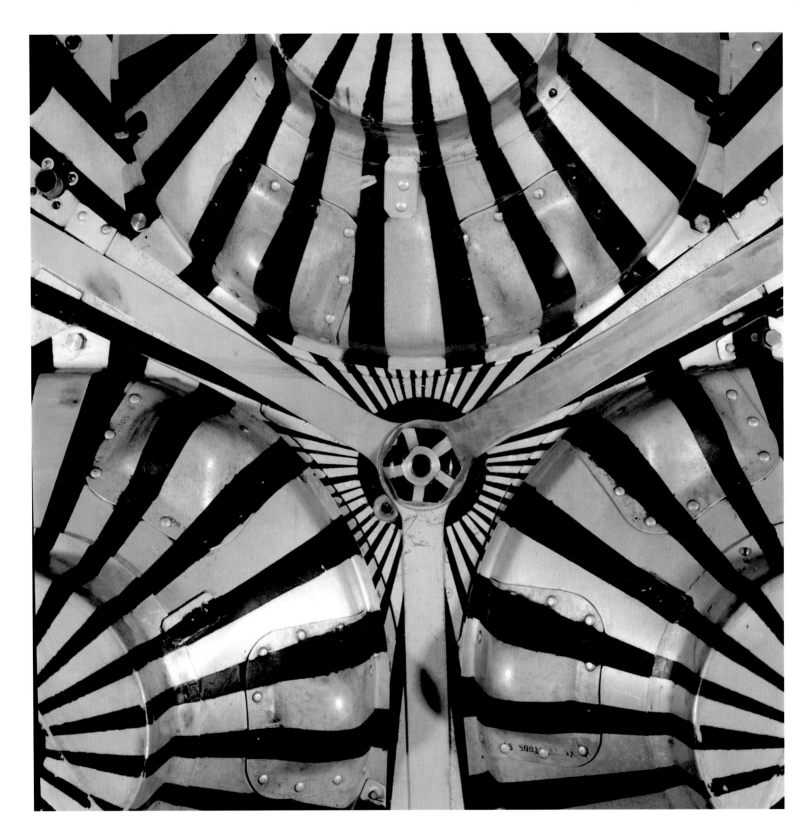

Mercury Capsule 15B
Freedom 7 II

>>*Retrorocket Pack*

The pattern of stripes and circles are rockets located on the base of the *Freedom 7 II* space capsule. The spacecraft had three small rockets to separate it from its booster, and three large retrorockets to slow the capsule and bring it out of orbit.

Alan Shepard's flight on May 5, 1961, in his *Freedom 7* Mercury capsule was brief but historic. The suborbital flight lasted only about 15 minutes, but they included the first minutes any American had spent in space. With fellow Mercury Seven astronaut Deke Slayton sidelined for medical reasons, Shepard looked forward to another, much longer flight—the seventh Mercury mission—in 1963. He named his prospective ride *Freedom 7 II*.

But *Freedom 7 II* never flew. After a successful sixth Mercury mission, NASA canceled the seventh mission and moved on to the next phase of its human space flight program: the two-man Gemini missions. *Freedom 7 II* remains one of only two Mercury capsules still in its orbital configuration, complete with the silver and black retrorocket package used for slowing its return to Earth, and with parachutes for final descent still packed

away in its nose.

Both Shepard and Slayton took part in subsequent missions. Shepard flew on Apollo 14 in 1971 and spent a record 33 hours on the Moon and more than 9 hours exploring its surface. Slayton finally flew in 1975 on the Apollo-Soyuz Test Project, a joint U.S.-Soviet flight that culminated with the historic first meeting in space of astronauts and cosmonauts.

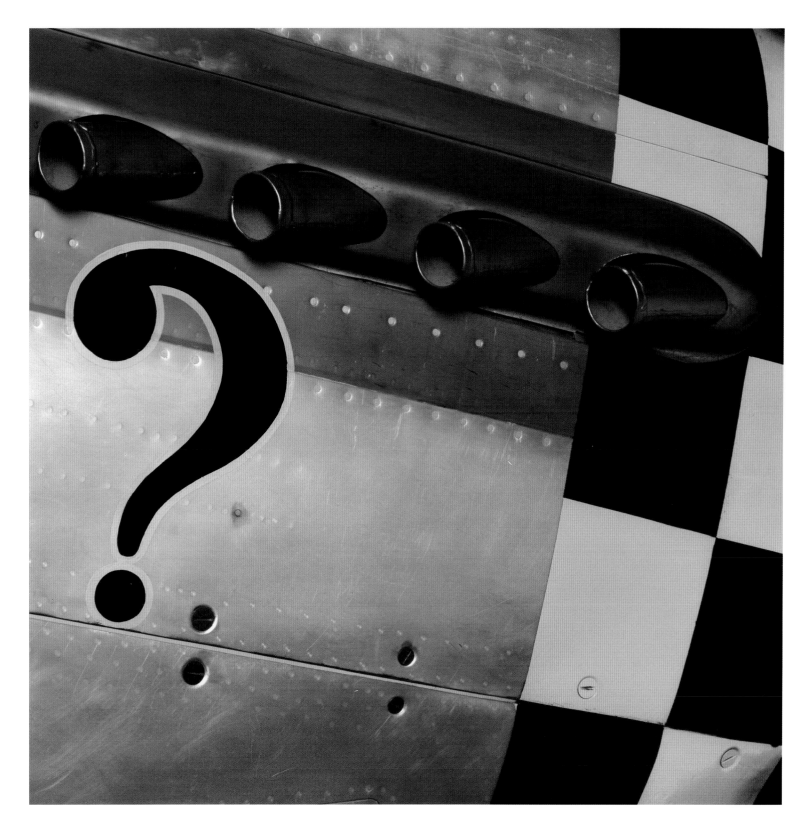

North American P-51D Mustang Willit Run?

>>Forward Fuselage

The P-51 has 12 of these engine exhaust pipes, six on each side. The aircraft's V-12 inline engine has no muffler, so during takeoff a Mustang sounds like a gang of motorcycles roaring at wide-open throttle. The question mark punctuated the airplane's name, *Willit Run?*

The world's best long-range, propeller-driven escort fighter was an American creation with a strong British influence. North American Aviation originally built it for the British in 1940, seeking to improve upon the Curtiss P-40, the best—and only—U.S. land-based fighter at the time. It was the British who gave the P-51 its wild western name.

The British also equipped a few Mustangs with their own Merlin super-charged engines, which increased the aircraft's speed and range so much that Merlins became standard on P-51s. The Allies finally had an escort fighter that could defend squadrons of B-17 bombers throughout their long flights to Germany and back, and even strafe enemy aircraft and ground installations on the way home. Mustangs escorted B-29s in the Pacific too. In fact, they proved so valuable that some remained in service until 1957, well into the jet age.

The P-51D, with its distinctive bubble canopy and two additional .50 caliber machine guns (for a total of six) accounted for more than half of all Mustang variants. The Mustang now called *Willit Run?* indeed ran but did not fight, for the war was nearly over when it arrived. It now bears the colors and markings of the 351st Fighter Squadron of the U.S. Eighth Air Force.

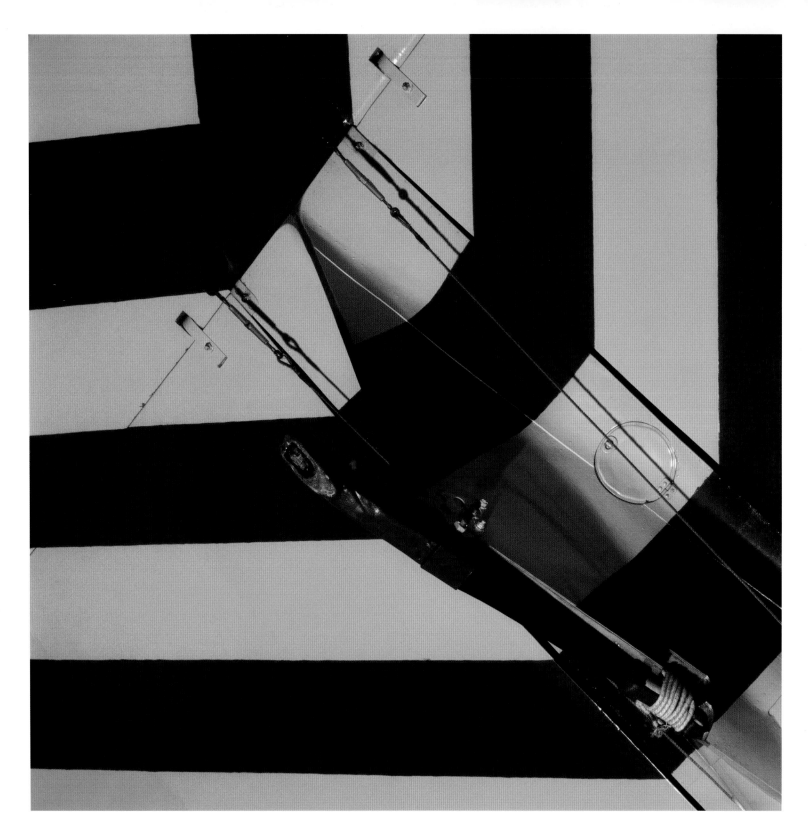

Albatros D.Va

>>Tail

The colors denote the German fighter squadron Jasta 46. Military units have long used bold colors and symbols to identify their squadrons. The metal-shod wooden tail skid supported the tail on the ground.

The changing tides of technological advantage during World War I prompted the creation of new aircraft designs and the modification—but not always improvement—of existing ones. Germany's series of Albatros fighters illustrates this technological tug-of-war.

The first Albatros, the D.1, was designed to counter increasing Allied air superiority. With its sleek plywood fuselage, enclosed in-line engine, and neatly contoured propeller spinner that brought the nose to a streamlined point, it set a new standard for single-seat fighters. The D.I and similar D.II captured the edge in speed and firepower—for a time. Albatros kept tinkering with the design, downsizing the lower wing to make the D.III more maneuverable and to enhance the pilot's view. However, the wing had the disconcerting habit of collapsing during dives and had to be reinforced.

The French and British, meanwhile, brought out new and better designs. Albatros countered again, but its D.IV, with an experimental geared engine, was a complete failure. The D.V, with its elegantly rounded fuselage, looked great but suffered from upper wing failure. The wing spar and ribs were strengthened, creating the D.Va, but the added weight offset the airplane's other improvements. Ultimately, Germany's Fokker D.VII took the lead, and the Albatros line languished.

Ford 5-AT Tri-Motor

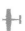

>>Doorway and Corrugated Aluminum Skin

The name of the airline, American Airways, was painted over the doorway for publicity purposes. Photographers would snap photos of celebrities and high-society travelers as they arrived, and airlines capitalized on the free advertising.

Air travel was a novel experience in the 1920s, one that fairly few tried. Besides the expense, people had concerns—not unfounded—about how safe flying was. Ford, producer of those reliable automobiles Americans enjoyed, helped alleviate the fears of potential passengers when it brought its prestige and reputation for quality products into the realm of aviation.

When the Ford Tri-Motor first flew in 1926, it was the largest civil aircraft in America. It was made entirely of metal; it had a strong, corrugated aluminum fuselage; and the first production version, the 4-AT, was powered by three reliable Wright J-5 Whirlwinds, the first modern aircraft engine. The 5-AT, introduced in 1928, had even more powerful Pratt & Whitney Wasps. Airlines across America were soon flying them, and the "Tin Goose" quickly won the trust of air travelers.

Which is not to say that Tri-Motors were entirely pleasant to fly in. Pressurized cabins were still a thing of the future, so airplanes flew at low altitudes, subject to the whims of wind and weather. Air sickness was not uncommon, and passenger cabins were unheated. And Tri-Motors were almost painfully loud; flight crews passed out earplugs and sometimes used small megaphones to communicate with passengers.

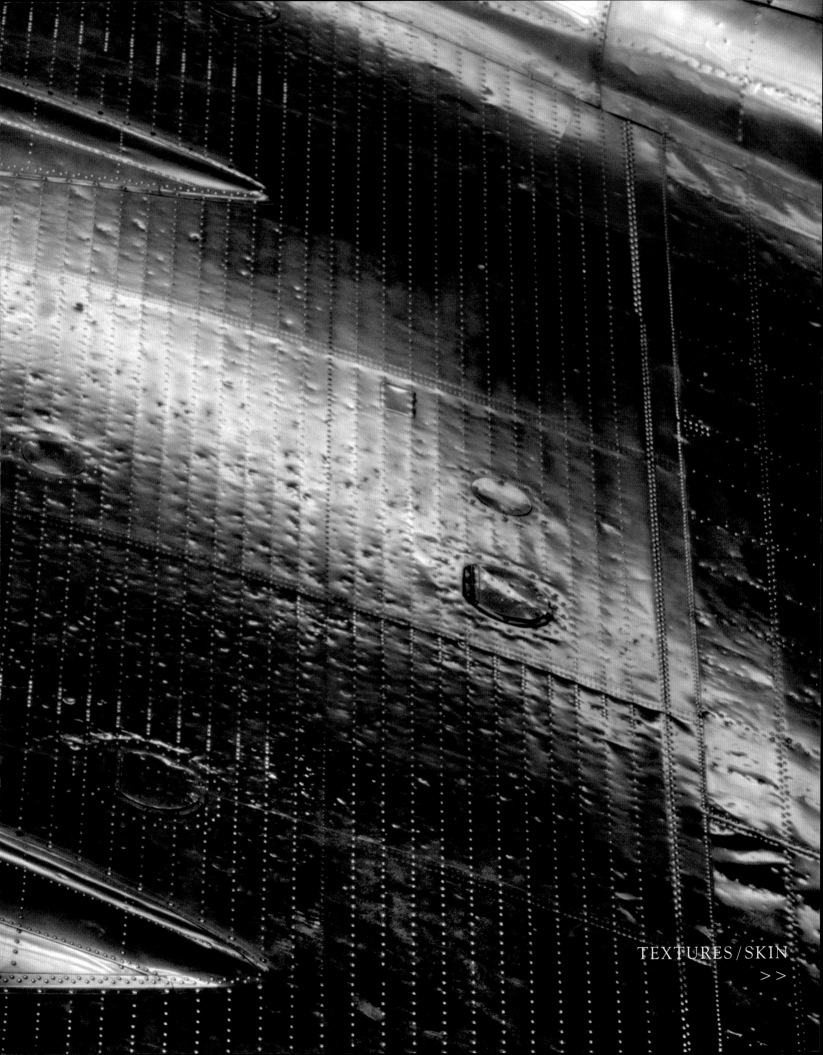

Halberstadt CL.IV

"For not only is life put in new patterns from the air, but it is somehow arrested, frozen in form."

—*Anne Morrow Lindbergh*
Aviator and writer

Just as the view from an airplane's window transforms the landscape into a tapestry of shapes and colors, so does Carolyn Russo's unique perspective make visible the distinct surfaces that protect and identify flying machines, like skin marks and envelops living organisms. Focusing on these delicate membranes, Russo reveals patterns and textures that often escape our notice, but which create analogies between our own bodies and those of aircraft. The feel of skin is lusciously evoked by a photograph of the Turner RT-14 Meteor wheel fairing. Flown by the barnstorming air racer and entrepreneur Roscoe Turner, the smooth curves evoke those of a reclining nude.

Russo's unusual view of the Apollo 11 Command Module *Columbia* does not focus on its iconic shape. Instead, the photographer focuses on its side, which is rarely pictured. In this view, the command module is flattened into a suggestive, seemingly crater-filled landscape— not unlike the Moon, or perhaps even the rust-colored deserts of the Earth that Command Module Pilot Michael Collins observed from outer space in 1969.

A similar pattern emerges in the photograph of the Soyuz TM-10 Landing Module. The searing heat of reentry leaves pockmarks and scars that provide a visual interest of their own, not unlike the lines and wrinkles acquired over a human lifetime.

Russo's picture of the Mercury *Friendship 7* evokes the radiating pattern left upon the space capsule's heat shield during the process of reentry. But the celestial appearance of the combination of darks and sparkling lights also evokes the glowing "fireflies" that John Glenn reported seeing during his cosmic voyage.

Pulled taut across dark struts, a bold swath of light-colored fabric belonging to the 1903 Wright Flyer conveys the restrained power of the "skin" that first produced heavier-than-air human flight. The elegant black-and-white geometry of the photograph recalls the early twentieth-century abstractions of the Suprematist artist Kazimir Malevich, whose fascination with flight grew into a spiritual philosophy. "If all artists could see the crossroads of these celestial paths," he claimed in 1915, "if they could comprehend these monstrous runways and the weaving of our bodies with the clouds in the sky, then they would not paint chrysanthemums."

from *North to the Orient*, 1935

>>Wheel

The inside of the wheel is covered with brightly colored camouflage fabric. A spare piece of fabric was stitched over a small section to access the air valve.

The use of aircraft in war was still something of an ongoing experiment throughout World War I, with new roles for aircraft being invented and new aircraft being adapted or designed to fill those roles. The Halberstadt CL.II, for example, was designed as a two-seat escort to protect reconnaissance and patrol airplanes from prowling enemy fighters. But it was so successful at ground attack that a new version was designed specifically for that role.

The new model, the Halberstadt CL.IV, retained the CL.II's single cockpit, with the pilot and observer/gunner/bombardier seated back to back. The pilot fired one or two fixed Spandau machine guns, while the observer fired a swivel-mounted Parabellum machine gun, so the airplane could rake the battlefield below both coming and going. The plywood-skinned fuselage was shortened and strengthened, and other design alterations improved

maneuverability. The result was one of the best ground-attack aircraft of the war.

The CL.IV began appearing on the Western Front toward the end of the German offensive of 1918, and it helped Germany break the trench warfare stalemate. Halberstadts also found gainful employment as escorts and interceptors, preying on Allied bombers returning from missions and attacking Allied airfields by night.

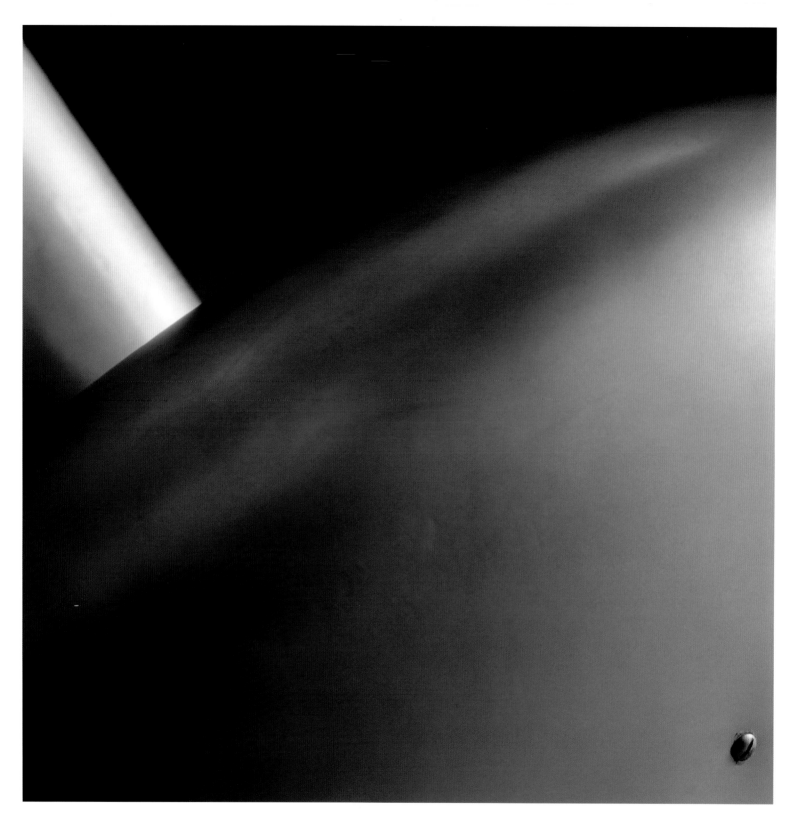

Turner RT-14 Meteor

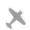

>>Wheel Fairing and Strut

Streamlined wheel coverings reduced the drag caused by fixed landing gear and its supporting struts. Such fairings were no longer needed once aircraft began incorporating landing gear that folded into the wings.

One of the most flamboyant and successful air racers of the 1930s, Roscoe Turner set seven transcontinental speed records, won the cross-country Bendix Trophy race, and won the prestigious closed-course Thompson Trophy race—the Indianapolis 500 of the air—three times, when no else had won it more than once. He would have won four times had he not missed a pylon on the last lap one year.

Turner won his early races in a Wedell-Williams racer, but by the mid-1930s, he knew he needed a faster plane to keep on winning. So with the help of an engineering professor, he designed the Turner Meteor. Once built, the wingspan turned out to be inadequate, so Turner called on renowned aircraft designer Matty Laird to help create a new one. The resulting Turner-Laird airplane proved to be all Roscoe had hoped for.

For the next three years he became the man to beat at the National Air Races, placing third in the Thompson in 1937 (thanks to that missed pylon) and winning it the next two years. He renamed the airplane each year after his current sponsor: *Ring Free Meteor* (Ring Free Oil), *Pesco Special* (Pump Engineering Service Corporation), and *Miss Champion* (Champion Spark Plugs). After his third Thompson win, Turner hung up his racing goggles and called it quits.

McDonnell F-4S Phantom II

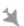

>>*Inlet Ramp*

The tiny holes on the inlet ramp help to
diffuse the air moving into the engine inlet
when the aircraft is flying at high speed. >>see **P.46–47** for more.

Curtiss IA Gulfhawk

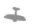

>>*Bump Engine Cowling*

The bulges in the cowling were made to accommodate the tops of the engine's cylinder heads and spark plugs.

A one-of-a-kind airplane with a complicated heritage, the *Gulfhawk* was named and flown by renowned aerobatic pilot Al Williams during the early 1930s. Williams, a record-setting racer and former U.S. Navy chief test pilot, was known for air show routines that ended with dive-bombing demonstrations, a not-so-subtle way of promoting military aviation.

The *Gulfhawk* began as a Curtiss Navy F6C-4 Hawk that incorporated elements of the Army's version, the P-1. If that wasn't confusing enough, the aircraft was further modified after a crash into a Hawk 1A with the installation of a Wright Cyclone engine. Williams bought it in 1930, replaced the engine yet again (with a Bristol Jupiter 9) and made other refinements. A more serious crash after an engine failure during an air show prompted a complete rebuild. Williams installed a different Cyclone, reconstructed the fuselage, and replaced the fabric skin with aluminum.

Now associated with Gulf Oil, Williams gave the *Gulfhawk* its famous Gulf orange, white, and black sunburst paint scheme. He flew the aircraft on the air show circuit under Gulf sponsorship through 1936, when he switched to a new airplane, the *Gulfhawk II*. Movie and aerobatic pilot Frank Tallman later bought the *Gulfhawk*, restored it, and returned it to the air show circuit during the 1960s.

Boeing 307 Stratoliner
Clipper Flying Cloud

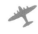

>>*Wing*

The all-metal wing is polished to a high gloss. The engines are beautifully faired into the wing.

Air travel took a leap upward in the late 1930s when Boeing introduced the Stratoliner, the world's first pressurized airliner. While other airliners could fly no higher than about 10,000 feet, where storms and rough air could toss them about, the Stratoliner cruised as high as 25,000 feet, where the going was smoother and faster. Travelers could relax in reclining seats or snooze in sleeper berths.

The 307's wings, tail, and engines were taken from Boeing's B-17C bomber, while the fuselage was based on the technology of the XC-35, an experimental, pressurized Lockheed Electra. Only 10 Stratoliners were built, before World War II intervened. The prototype was lost in a crash. TWA bought five, Pan American Airways three, and Howard Hughes bought one he intended to use to break the round-the-world

speed record. He never made the trip and sold the airplane; its fuselage ended up as a houseboat named *Cosmic Muffin*.

Pan Am's *Clipper Flying Cloud* is the only Stratoliner left. Boeing restored it to pristine condition.

Apollo 11 Command Module
Columbia

"[From the Moon] You don't see the land, surprisingly enough, that prominently. You see some of the deserts, the North African desert, where they have a lot of iron oxide, sort of a smear of rust color."

—*Mike Collins*
Command Module Pilot of Apollo 11

from the Space Lecture Series at the National Air and Space Museum, 1988

>>*Heat Shield*

The roundel appears on both sides of the fuselage and wings. The emblazoned marking easily identified the aircraft as belonging to the Royal Air Force.

The *Columbia* represents one of the most monumental milestones in the history of flight: the first visit by human beings to the surface of another world. In July 1969, *Columbia* carried astronauts Neil Armstrong, Edwin "Buzz" Aldrin, and Michael Collins to the Moon. Once in lunar orbit, Armstrong and Aldrin boarded the attached lunar module *Eagle*, and on July 20 they descended to the surface. A few hours later, Armstrong stepped out onto the Moon.

The snug crew compartment in the command module, their home base during their eight-day mission, contained three couches all facing the main control panel. The couches could be folded up to create more room, and it was even possible for an astronaut to stand and stretch. The forward compartment in the nose contained parachutes and recovery apparatus, and the aft compartment behind the couches housed other equipment.

The service module, the other section of the three-part spacecraft, contained the propulsion system and the spacecraft's supplies of water, oxygen, hydrogen, and propellants. The service and lunar modules were left behind; only the command module returned to Earth. Its epoxy-resin ablative heat shield protected it from the 5,000 °F temperatures created by its 25,000-mile-per-hour plunge through the atmosphere.

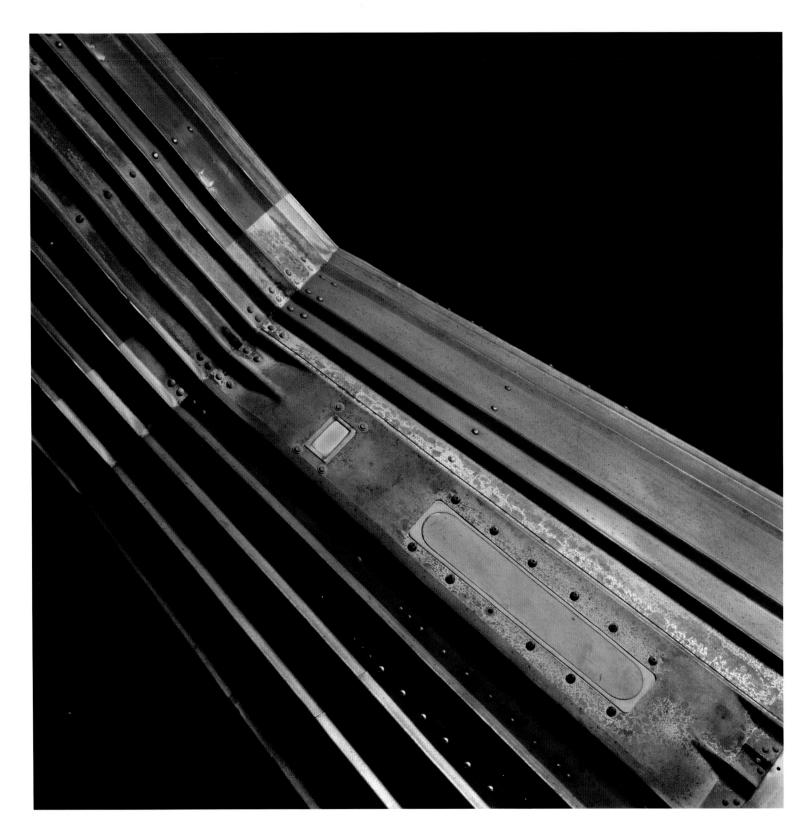

Mercury Capsule "Big Joe"

>>*Capsule Exterior*

This early space capsule was created to test the shape and ablative shield during all phases of space flight. The corrugation of the Inconell alloy (nickel chromium) exterior was designed to withstand the heat of reentry.

More than a year and a half before President John F. Kennedy committed the United States to a program to land men on the Moon, NASA was already working toward making manned spaceflight a reality. America had been beaten into space by the Soviet Union, which stunned the world by launching Sputnik, the first artificial satellite in October 1957. The next prestigious "first" at stake was putting a man in space.

On September 9, 1959, NASA launched an unmanned Mercury spacecraft, nicknamed "Big Joe," from Cape Canaveral, Florida, on a 13-minute suborbital flight. "Big Joe" was the second unmanned Mercury test flight, the most massive American spacecraft yet launched, and the first launched by an Atlas booster, the vehicle NASA would use to place Mercury astronauts into orbit. "Big Joe" helped NASA evaluate the Atlas booster,

the new ablative heat shield, spacecraft shape and flight dynamics, and recovery systems and procedures.

On May 5, 1961, astronaut Alan Shepard became the first American to enter space on a brief suborbital flight. Once again, the Soviet Union had gotten there first—cosmonaut Yuri Gagarin had circled the Earth a month earlier—but the U.S. space program was on track and shooting for the Moon.

Robinson R44 Astro
G-MURY

>>*Engine Air Cooling Vent*

The helicopter's piston engine is mounted in the rear of the fuselage and has two cooling vents on either side.

The arrival of the jet age affected not only fixed-wing aircraft but also helicopter designs. Turbine rather than piston engines became the standard for most new models beginning in the mid-1950s. Frank Robinson bucked that trend when he developed his R22, then again in 1992 when he introduced the R44 Astro.

Robinson had founded Robinson Helicopter in 1973 to produce small, low-cost general aviation helicopters. The R44, his second model line, fit that goal well. Its economical reciprocating engine and simple teetering rotor system kept the price down without compromising performance. Upgraded versions of the R44 followed, some with fixed or pop-out floats for water landings and others specifically designed as police helicopters and newscopters. The R44 became the world's top-selling helicopter, and Robinson became the highest-volume producer of civil helicopters.

The R44 Astro G-MURY has the distinction of having circled the globe twice. In 1997, Jennifer Murray, with her instructor Quentin Smith, became the first woman to pilot a helicopter around the world and the first person to do so in a piston-powered helicopter. Three years later she performed the feat again solo, also a first for a woman. Each trip took about three months.

Vertol VZ-2

>>Fairing

The fairing aft of the cockpit is a protective covering for the aircraft structure. The deterioration of the outer surface suggests the need for restoration.

An aircraft that could perform both as helicopter and airplane, combining vertical and horizontal flight, has long been an aeronautical goal. The U.S. military took interest in the 1950s and began studying various proposals for a Vertical Takeoff and Landing (VTOL) craft. Some involved tilting rotors, propellers, or jets; others tilting the entire wing, engines and all; others used tilt ducts, lift fans, or deflected thrust.

Vertol Aircraft produced for the Army the Vertol VZ-2, a tilt-wing design. The ungainly looking craft first flew vertically in 1957, although nearly a year passed before it successfully made an in-flight transition from vertical to horizontal flight, its wing pivoting from vertical to horizontal along with its engines and propellers—the first tilt-wing aircraft ever to do so.

The tilt-wing concept seemed simple, as only one major element—the wing—moved. But the need for separate control systems for vertical and horizontal flight offset this advantage. Competing concepts proved more viable. The VZ-2 led to larger tilt-wing projects, such as the Hiller X-18, the LTV-Hiller-Ryan XC-142, and the Canadair CL-84. However, by the mid-1970s, the tilt-rotor had emerged as the most efficient option for VTOL transport.

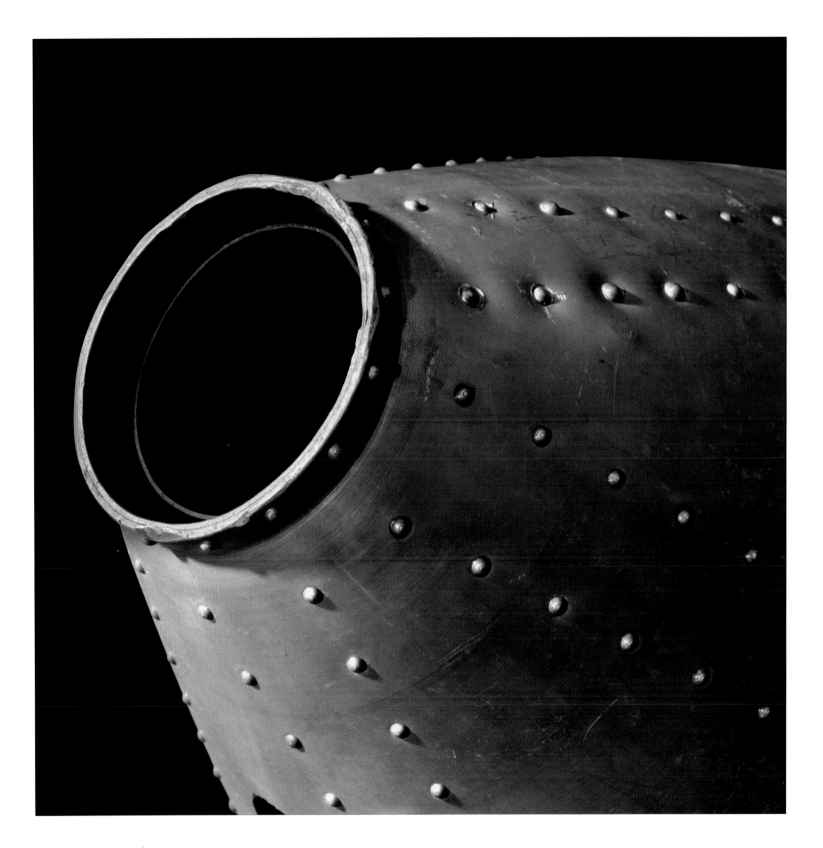

Arado Ar 234 B Blitz

>>*Rocket-Assisted Takeoff Unit (RATO)*

The expendable RATO units are located under the wings outboard of the jet engines. The RATO units assisted with thrust during takeoff and were then released. The protruding small bumps are raised rivets.

>>see **P.39** for more.

Mercury Friendship 7

"Aviation is proof that, given the will, we have the capacity to achieve the impossible."

—Eddie Rickenbacker
World War I ace pilot and a pioneer in commercial aviation

from *Slipping the Surly Bonds*, 1998

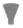

>>*Heat Shield*

The blunt end of the Mercury capsule, like those of Gemini and Apollo spacecraft, helped slow the craft during reentry. The heat shield protected against the extreme temperatures and partly eroded away from reentry heating.

On February 20, 1962, John H. Glenn Jr. rocketed into space and international fame aboard the Mercury capsule he had named *Friendship 7*. Four men had preceded him into space: two Soviet cosmonauts who had orbited the Earth and two fellow astronauts who had arced briefly into space. But Glenn was the first American to go into orbit, and his flight reassured the nation that the United States was still very much in the Space Race.

The main part of the capsule snugly contained Glenn and his form-fitting couch, along with the life-support and electrical power systems. Atop the capsule was a cylinder containing the parachutes used during landing. Covering the blunt bottom of *Friendship 7* was the all-important ablative heat shield, without which both capsule and astronaut would burn up during reentry.

Thus, flight controllers were shaken during the mission by a warning light indicating that the heat shield and compressed landing bag behind it had come loose. They decided to keep the retrorocket package (meant to be jettisoned) strapped over the heat shield, hoping it would hold the shield in place during reentry. As it turned out, it was a false alarm, and Glenn safely returned to Earth after completing three orbits.

GOES Satellite

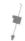

>>*Solar Sail Boom Section*

The solar sail boom is covered with gold-colored Kapton. Kapton is an aluminized material that reflects heat and controls the thermal balance of the satellite.

GOES satellites provide much of the imagery from space so familiar to viewers of television weather reports. A GOES (Geostationary Operational Environmental Satellite) is placed 22,300 miles above the equator, where it orbits at the same speed as the Earth rotates and therefore remains fixed over one spot on the ground. A pair of GOES satellites constantly monitors the weather across 60 percent of the Earth's surface.

Several generations of increasingly sophisticated GOES satellites have been launched since 1975. An imaging sensor records, in visible and infrared wavelengths, radiant and reflected energy from the Earth's surface and atmosphere. A sounder gathers data on atmospheric temperatures and moisture, surface and cloud top temperatures, and ozone distribution. A host of other instruments monitor the near-Earth environment or provide other services.

Providing data for forecasting weather events—including rain and snow storms, hurricanes, tornadoes, and flash floods—is the satellite's main function. But GOES observations have also been used to monitor dust storms, forest fires, and volcanic eruptions. Combined with Doppler radar and advanced communications systems, GOES satellites have improved forecasting tremendously, providing life-saving warnings of weather on its way.

The GOES artifact in the Museum's collection is a 1/2-scale model.

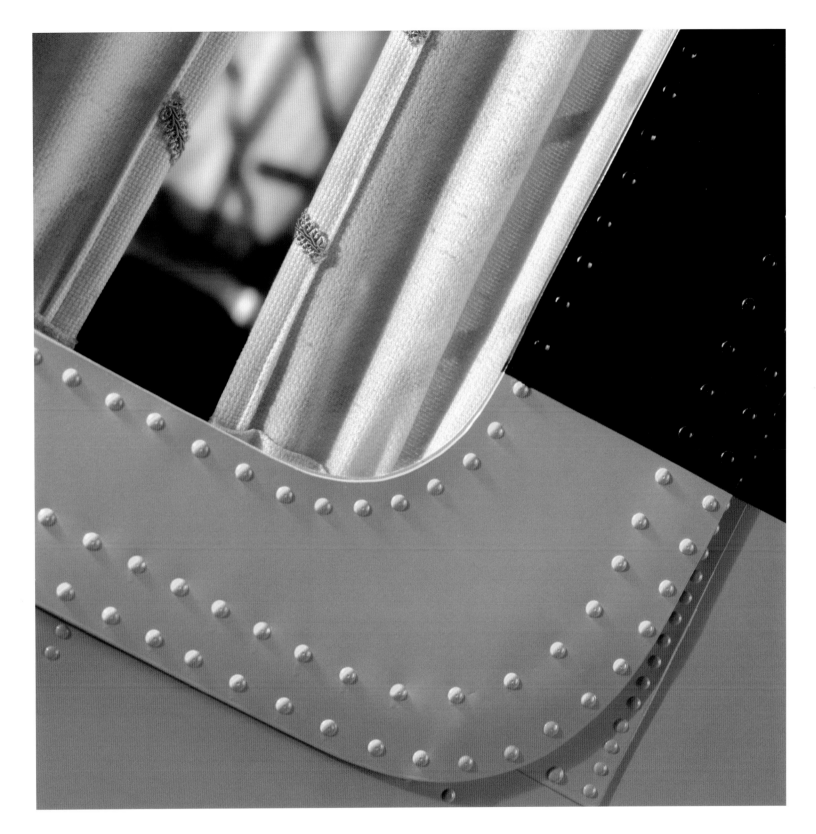

Grumman G-21 Goose

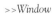

>>Window

The many dots on the metal are rivet heads anchoring the window frame to the fuselage to create a watertight seal. Behind the window are curtains for the passenger's comfort.

The affectionately nicknamed "Goose" was conceived as the ultimate limousine, an amphibious commuter plane for whisking prominent New York businessmen between their Long Island mansions and the seaplane docks near their Manhattan offices. But word of the versatile airplane got around, and military and corporate customers were soon knocking on Grumman's door.

Introduced in 1937, the Goose was a new sort of bird for Grumman: its first single-wing and twin-engine aircraft and its first, if somewhat accidental, commercial airliner. Its hull-shaped fuselage and wing-mounted floats enabled the Goose to alight on water as well as land, and it could carry up to six passengers. While the likes of Wilton Lloyd-Smith, Marshall Field III, and Lord Beaverbrook were enjoying their swanky new "air yachts," Grumman was busy filling orders from airline, military, and foreign buyers smitten with the plane's potential.

Ultimately, military services of 11 nations, from the U.S. Army, Navy, and Coast Guard to the Peruvian air force and Portuguese navy, flew G-21s. After World War II, they became especially popular among small airlines in the Caribbean, California, and Alaska. Grumman produced its 345th and final G-21 in 1945, but some Gooses are still flying today.

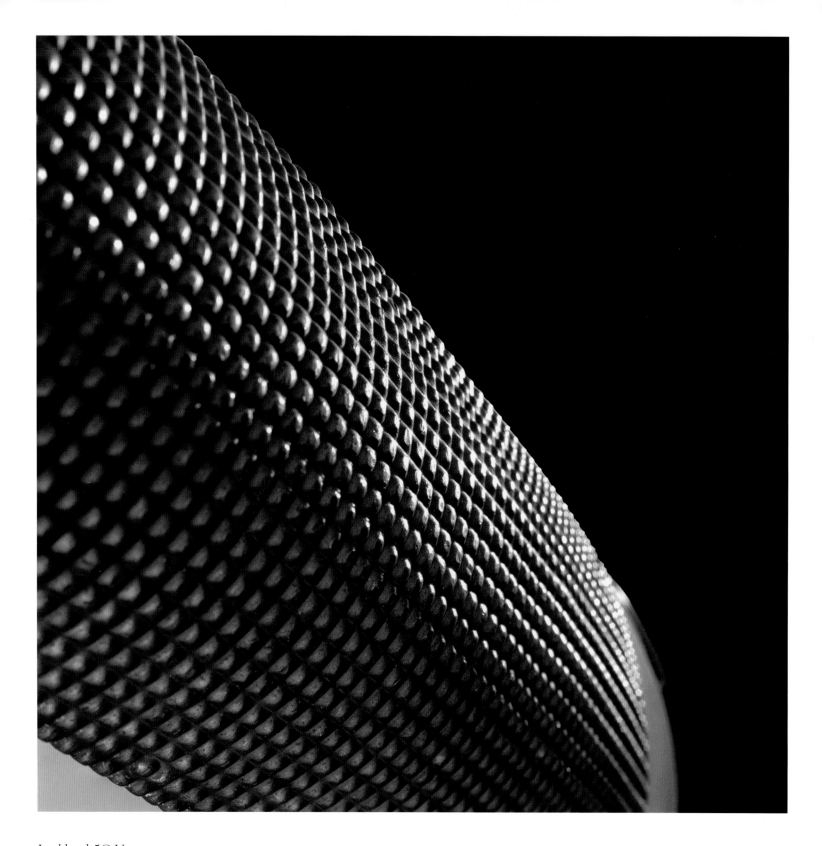

Lockheed 5C Vega
Winnie Mae

>>*Wheel Fairing*

The wheels were not retractable, so a
streamlined covering encased them to reduce
drag. A step pad was added on top of the
wheel fairing so one could step on the curved
fairing without slipping or damaging it.

>>see **P.98** for more.

Sikorsky JRS-1

>>*Rudder*

Age and the elements have broken and peeled away the fabric covering, revealing the underlying structure. Restoration certainly is in order for this historic aircraft.

In 1935, Sikorsky Aircraft rolled out a smaller, two-engine version of its big four-engine S-42 flying boat, an aircraft that had become famous as part of Pan American Airways' "Clipper" fleet. The S-43 "Baby Clipper" could easily alight on runways or water, thanks to its retractable landing gear, hull, and wing-mounted floats. Its passengers (it carried up to 15 of them) entered and exited the airliner from a hatch in the top of the cabin toward the rear.

Pan Am used S-43s on its Caribbean and Latin American routes and later in Alaska as well. Other airlines flew them in places as diverse as Hawaii, China, Norway, the Philippines, Russia, and West Africa. William Vanderbilt bought one and outfitted it as an "air yacht." Howard Hughes bought another to use for a round-the-world record flight, which he ultimately made in a Lockheed Super-Electra instead. The U.S. Navy, Marine

Corps, and Army purchased some as well for use as transports. The Navy/Marine version was called the JRS-1.

The Museum's JRS-1 was one of 10 stationed in Hawaii on December 7, 1941, all of which survived the Japanese attack that morning. Armed with bombs and depth charges attached to its wings, it was one of the first airplanes launched afterward to search—unsuccessfully—for the Japanese fleet.

Focke-Wulf Ta 152 H

"…[N]ew needs need new techniques. And the modern artists have found new ways and new means of making their statements…[T]he modern painter cannot express this age, the airplane, the atom bomb, the radio, in the old forms of the Renaissance or of any other past culture."

—*Jackson Pollock*

from an interview with William Wright

>>*Fuselage Section*

The various paint colors beneath the stripped surface were applied by both Germans and Americans. Restorers often search for clues before restoring aircraft back to their original state. The yellow and red colors visible in this section are the colors of Luftwaffe Fighter Wing 301.

The Focke-Wulf Fw 190 was one of the most feared German fighters of World War II. Its close relative, the Focke-Wulf Ta 152 H, might have made as great an impression, but time and the tide of war were not in Germany's favor. The aircraft was introduced prematurely, still plagued with bugs, and too late to make much of a difference anyhow. All the aircraft really had going for it was its potential.

The Ta 152 H was basically an Fw 190 redesigned to intercept Allied bombers and their escorts flying at higher altitudes than most German fighters could reach. The "Ta" designation honored the aircraft's chief designer Kurt Tank for his previous designs, which included the Fw 190.

Starting with the basic Fw 190 design, engineers completely redesigned the wings, greatly extended their span, and modified the fuselage. But the engine, supercharger, pressurization equipment, and other systems proved troublesome. Materials shortages due to Allied bombing attacks and quality control problems added to their headaches. Production forged ahead (fewer than 70 aircraft were produced), but performance in the field disappointed. Still, the Ta 152 H was faster and more maneuverable than a Mustang or a Thunderbolt, but by 1945 that hardly mattered.

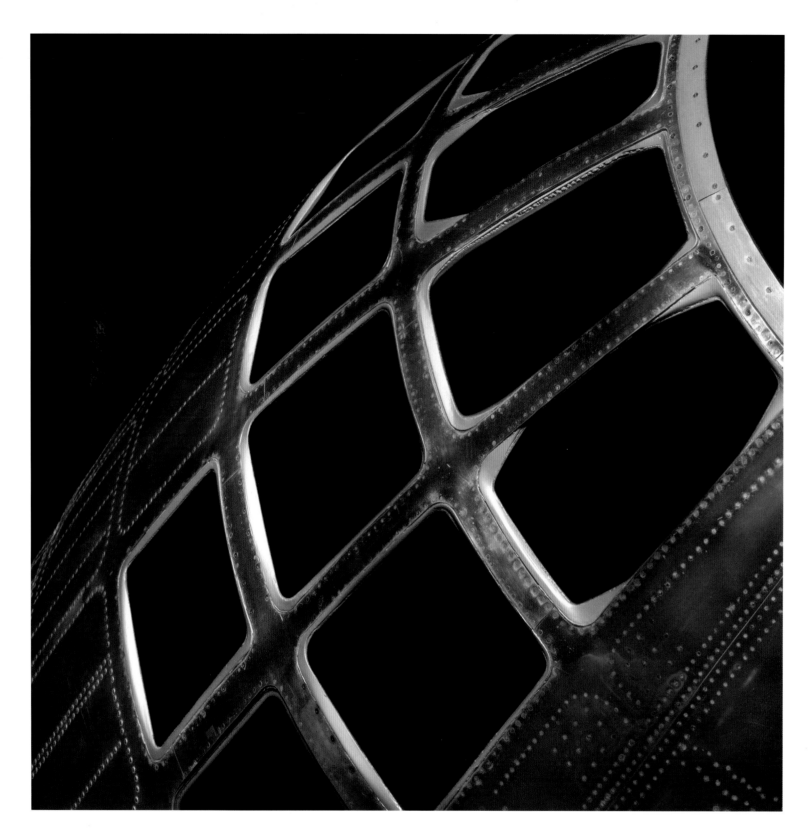

Boeing B-29 Superfortress
Enola Gay

>>Cockpit Windows

The rounded Plexiglas panes allow for full visibility in the nose section for the pilots and bombardier. The compartment was pressurized in flight, so each pane was tightly secured by seals and rows of rivets.

The *Enola Gay* dropped the first atomic bomb ever used in war on Hiroshima, Japan, on August 6, 1945. Since then, people have argued bitterly about the necessity, consequences, and morality of that action. Less subject to debate, however, is the huge technological leap the B-29 represented.

Boeing didn't name it the Superfortress for nothing. It far exceeded, in sophistication and performance, its renowned predecessor, the Boeing B-17 Flying Fortress. It was the first bomber with pressurized crew compartments, and its innovative wing design (long and narrow with big Fowler flaps for slower landing and takeoff speeds) enabled it to fly fast at high altitude. It bristled with guns operated by remote control. It had advanced radar equipment and avionics and four powerful Curtiss-Wright R-3350 turbo-supercharged engines.

The *Enola Gay* was extensively modified for its unique mission. To accommodate the heavy 8,900-pound "Little Boy" atomic bomb, the bomb bay was reconfigured, faster pneumatic bomb bay doors were installed, and the airplane was lightened by removing its armor plate and four of its five gun turrets. A new fuel injection system and Curtiss Electric reversible-pitch propellers were added as well.

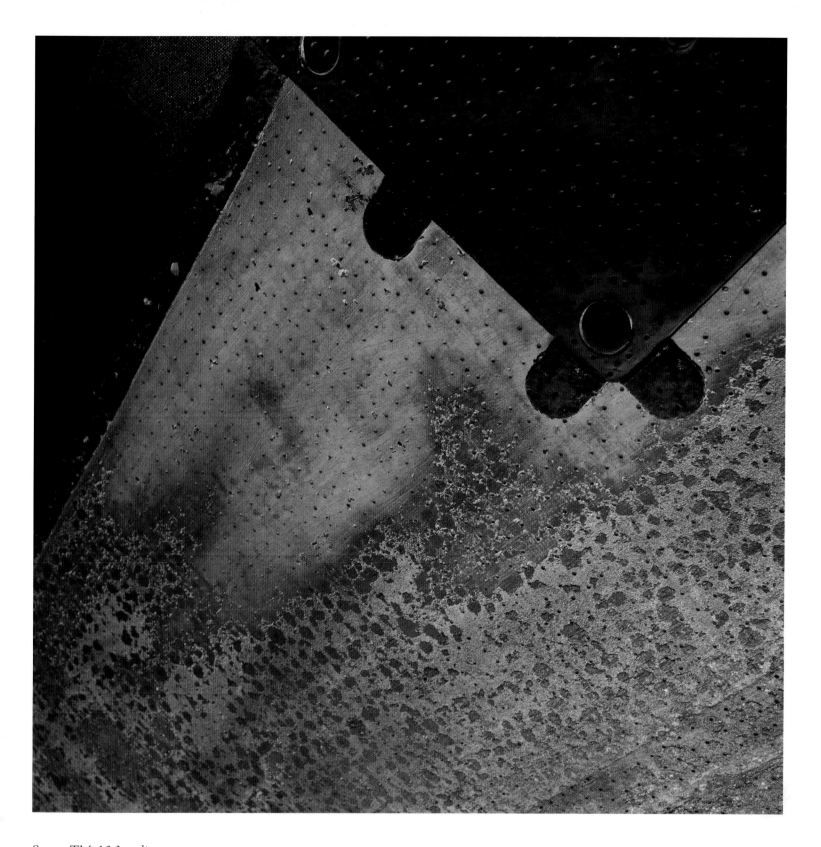

Soyuz TM-10 Landing Module

>>*Module Exterior*

The lighter textured area is where the outer
skin of the spacecraft was ablated away
during reentry.

>>see P.99 for more.

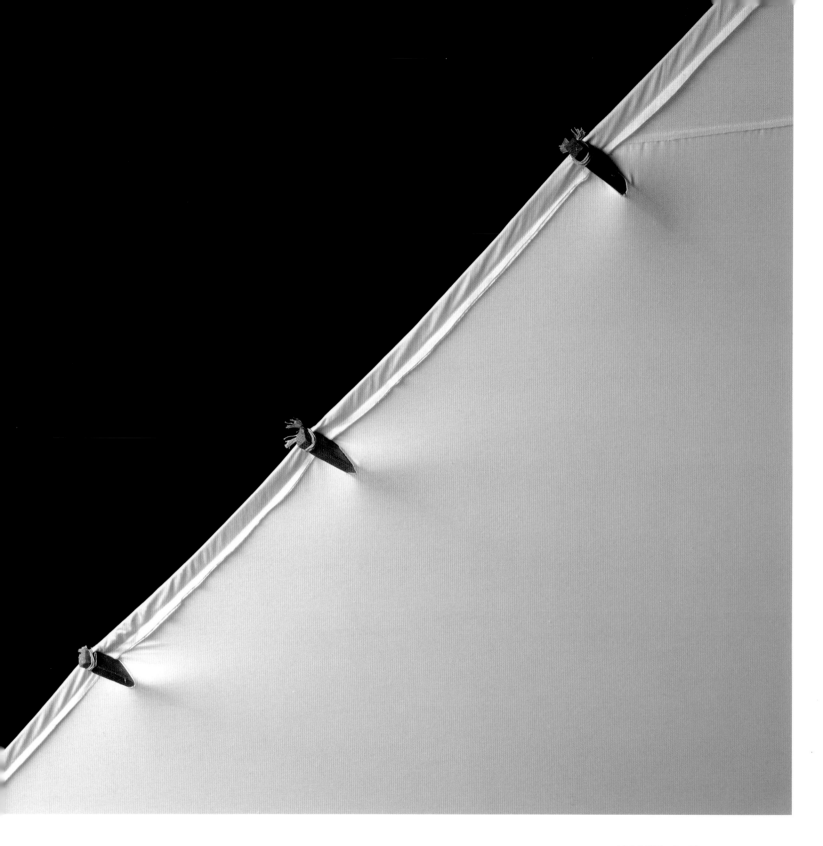

1903 Wright Flyer

"And this flight we wave
At the stars and moon
Means that we approve
Of things on the move,
Be they stars or moon.
Ours is to behave
Like a kitchen spoon
Of a size Titanic
To keep things stirred
In a blend mechanic,
Saying that's the tune
That's the pretty kettle!
Matter mustn't curd
Separate and settle.
Motion is the word."

—Robert Frost

from *Kitty Hawk*, 1957

>>*Wing*

Simple materials of fabric, wood, wire, and string form the trailing edge wing of the world's first airplane.

The success of the world's first airplane was no stroke of luck or serendipity on the part of a couple clever bicycle mechanics. It was the hard-earned result of a methodical program of research and development that took four and half years, during which two gifted inventors invented aeronautical engineering along with the airplane.

The achievements of Wilbur and Orville Wright during those four years went far beyond the 98 seconds their airplane spent in the air during its four flights on December 17, 1903. They created a completely new system of aircraft control based on aerodynamics rather than shifting the pilot's weight. To fashion an efficient wing, they produced their own body of aerodynamic data by studying how different wing shapes performed in a wind tunnel they built themselves. They crafted the propellers as rotary wings—airfoils rather than flat paddles—to make them more efficient. They began with a biplane kite, then built a series of three piloted gliders and made hundreds of test flights, the successes and failures of each one influencing the next.

And after 1903 they continued refining their invention. In 1905, while other airplanes were barely getting off the ground, the Wright brothers' third powered airplane flew for 39 minutes and 24 1/2 miles. The aerial age had finally arrived.

Junkers Ju 52/3m

>>*Aircraft Skin*

Irregular patterns of rivet heads look like beads of water. Some hold two pieces of the metal skin together; others attach the skin to the underlying airframe structure. The corrugation increases strength—and drag.

Descended from a line of pioneering all-metal aircraft created by the German Junkers company, the Ju 52/3m became one of the most successful European airliners ever built. Like the American Ford Tri-Motor, the Ju 52 had corrugated aluminum skin—ungainly looking today with its high aerodynamic drag, but a technological leap beyond the wood-and-fabric or metal-and-wood biplanes of the 1920s.

The Ju 52 debuted in 1930 as a single-engine aircraft designed to haul freight. Junkers created the tri-motor version, the Ju 52/3m, for the airline Deutsche Luft Hansa in 1932. The rugged airliner could carry 17 passengers or 3 tons of freight, and it could take off or land just about anywhere. Within a few years, airlines throughout Europe and Latin America were flying the Ju 52/3m, which pilots gave the less tongue-twisting nickname

Tante Ju—"Auntie Ju."

The aircraft played a significant military role as well. More than half went to the German Luftwaffe, which used the Ju 52/3m as its primary transport during World War II. Some even served as bombers. France and Spain built them as well, and many Ju 52/3m's continued to fly after the war, long after the brief heyday of corrugated metal airplanes had passed.

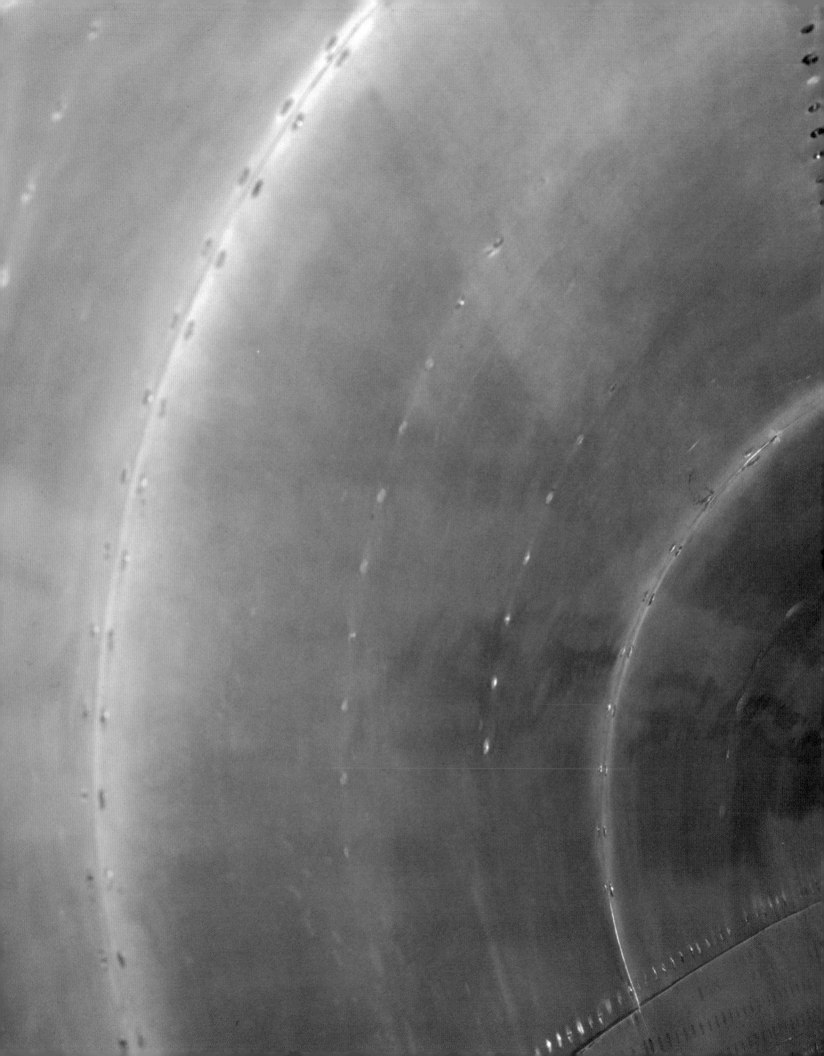

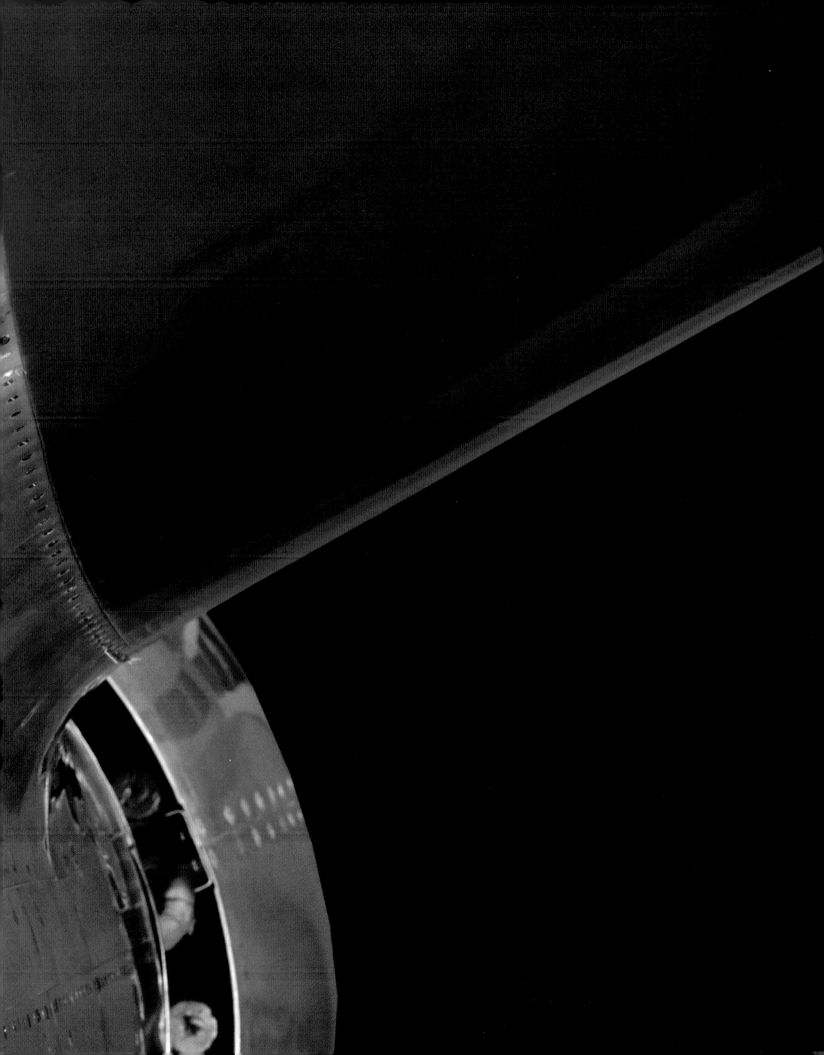

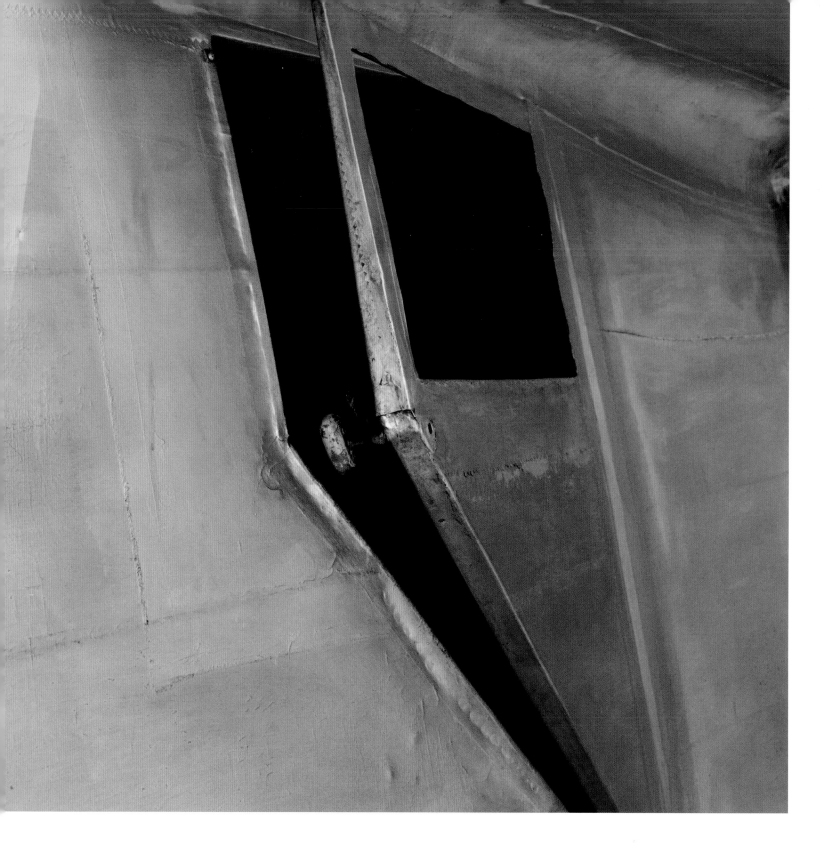

Ryan NYP Spirit of St. Louis

P.134–135. Hughes 1B Racer, Wing Fillet

"Certainly my visions in the Spirit of St. Louis entered into the reality of my life, for they stimulated thought along new lines: thought enters into both the creation and definition of reality…. I recognized that vision and reality interchange, like energy and matter."

—*Charles Lindbergh*

from *Autobiography of Values*, 1976

>>*Cockpit Door*

An extra fuel tank was mounted in the front cockpit where the windshield would have been, so the side windows and periscope provided the only views for Lindbergh.

In early 1927, Ryan Airlines in San Diego received a custom order for an airplane from a young air mail pilot who worked the St. Louis-Chicago route. Charles Lindbergh wanted to win the $25,000 prize (unclaimed since 1919) for the first nonstop flight from New York to Paris. He needed a reliable craft that could fly more than 3,500 miles without refueling. And with others vying for the prize, he needed it soon.

Ryan based the airplane on its standard high-wing, single-engine M-2. They extended the wingspan, beefed up the structure to carry a heavier fuel load, and installed a large fuel tank at the center of gravity (in front of the cockpit, blocking the pilot's forward view). They painted the wing and fuselage fabric silver. After a few test flights, Lindbergh flew the NYP (which stood for New York-Paris) to New York. On May 20, 1927, he took off and

headed east; the rest, as they say, is history.

The most famous pilot and most famous airplane in the world returned the following month aboard a Navy ship. Over the next year, Lindbergh toured the United States and Latin America in the *Spirit* and had the flags of the countries he visited painted on its side. A year after Ryan had completed the airplane, Lindbergh turned it over to the Smithsonian, where it hangs in a central place of honor today.

INDEX
>>

BIBLIOGRAPHY
> >

INTRODUCTION: On the relationship between flight and twentieth century art see: Houston Paschal and Linda Johnson Dougherty, eds., *Defying Gravity: Contemporary Art and Flight*, exh. cat. (Raleigh: North Carolina Museum of Art, 2003); Anne Collins Goodyear, "The Impact of Flight on Art in the Twentieth Century," in *Reconsidering a Century of Flight*, edited by Janet Bednarek and Roger Launius (Chapel Hill: University of North Carolina Press, 2003), p.223-241; Anne Collins Goodyear, Roger Launius, Anthony Springer, and Bertram Ulrich, eds., *Flight: A Celebration of Art and Literature* (New York: Welcome Books, 2003); Gerald Silk, "Our Future Is in the Air: Aviation and American Art," in *The Airplane in American Culture*, ed. Dominick A. Pisano (Ann Arbor: The University of Michigan Press, 2003), p.250-296; Robert Wohl, *A Passion for Wings: Aviation and the Western Imagination, 1908-1918* (New Haven: Yale University Press, 1994), esp. p.157-201; Kirk Varnedoe, *A Fine Disregard: What Makes Modern Art Modern* (New York: Harry N. Abrams, 1994 [1990]), p.216-77; and Julie H. Wosk, "The Aeroplane in Art," Art and Artists (December 1984), no. 219, p.23-28.

P.11. Amelia Earhart, *Last Flight* (New York: Harcourt, Brace and Company, 1937), p.29.

P.12. Marcel Proust, *Remembrance of Things Past: The Captive, The Fugitive, Time Regained*, translated by C.K. Scott Moncrieff, Terence Kilmartin, and Andreas Mayor (New York: Vintage Books, 1982), vol. 3, p.260.

P.17. Richard Bach, *A Gift of Wings* (New York: Delacorte Press, 1974), p.113.

P.21, 41. *We Saw It Happen*, a documentary film celebrating the 50th anniversary of flight, made in 1953 by United Aircraft Corporation (now United Technologies Corporation). The film and original outtakes belong to the Smithsonian Institution National Air and Space Museum Motion Picture Collection.

P.31. Dave English, ed., *The Air Up There: More Great Aviation Quotes on Flight* (New York: McGraw-Hill, 2003), p.3.

P.35. Interview with National Geographic Television at the National Air and Space Museum's Steven F. Udvar-Hazy Center, 2003.

P.47. Charles Lindbergh, *The Spirit of St. Louis* (New York: Charles Scribner's Sons, 1953), p.486.

P.51. Marvin W. McFarland, ed., *The Papers of Wilbur and Orville Wright, Volume Two: 1906–1948* (New York: McGraw-Hill, 1953), p.1169.

P.63, 121. Dave English, ed., *Slipping the Surly Bonds: Great Quotations on Flight* (New York: McGraw-Hill, 1998) p.40, 30.

P.69. speaking to the artist Constantin Brancusi at an air show before World War I, as quoted by the artist Fernand Léger (quoted in English translation in: K.G. Pontus Hultén, *The Machine as Seen at the End of the Mechanical Age*, exh. cat. [New York: The Museum of Modern Art, 1968], p.140; originally published in: Dora Vallier, "La vie fait l'oeuvre de Léger," *Cahiers d'Art* [1954], vol. 29, no. 2, p.133-172).

P.75. Conversation between Patty Wagstaff and Dorothy Cochrane (Aeronautics Curator at NASM) via e-mail on June 22, 2006.

P.81. *Sketchbook Notes*: Book A, p.8, c. 1960 (reprinted in: Kirk Varnedoe and Christel Hollevoet, eds., *Jasper Johns: Writings, Sketchbook Notes, Interviews* [New York: The Museum of Modern Art; distributed by Harry N. Abrams, New York, 1996], p.49).

P.85. *Great Aviation Quotes*, compiled by Dave English at http://www.skygod.com.

P.93. Donald S. Lopez, *Into the Teeth of the Tiger* (Washington and London: Smithsonian Press, 1997), p.114.

P.101. Betty Skelton, *Little Stinker* (Florida: Cross Press, 1977), p.34, 35.

P.109. Anne Morrow Lindbergh, *North to the Orient* (New York: Harcourt, Brace and Company, 1935 [1963]), p.137.

P.115. Space Lecture Series at the National Air and Space Museum, 1988.

P.127. Interview with William Wright (published in: Charles Harrison and Paul Wood, eds., *Art in Theory: 1900-1990*, [Oxford: Blackwell, 1995 (1992)], p.475).

P.131. *The Atlantic Monthly*, November 1957, p.56.

P.137. Charles Lindbergh, *Autobiography of Values* (New York and London: Harcourt Brace Jovanovich, 1976), p.12.

Permissions granted by Dave English from *Slipping The Surly Bonds: Great Quotations on Flight*.

Shaded symbols of aircraft and spacecraft are taken from plan view maps on the National Air and Space Museum's website. Photographs without symbols are either parts of aircraft and spacecraft or artifacts in storage at the Paul E. Garber Preservation, Restoration, and Storage Facility, located in Suitland, MD. Please visit www.nasm.si.edu for the Museum's complete collection.

ACKNOWLEDGEMENTS
>>

This book was made possible with the support of my family Robert A. Craddock, Maxwell Craddock, Jack Craddock, and several coworkers, collaborators, and friends.

I am truly grateful to Anne Collins Goodyear, Patty Wagstaff, Marquette Folley, David Romanowski, Ted Maxwell, Trish Graboske, Peter Golkin, Mark Taylor, Greg Bryant, Don Lopez, and Sue Steinberg, for their encouragement, assistance, and contributions towards this project. I thank powerHouse Books, especially Craig Cohen, Daoud Tyler-Ameen, and Mine Suda for a beautifully designed book. Thanks to Ramsey Gorchev who worked many late nights as my photography assistant, which made it possible for me to work throughout my pregnancy with my second son; and to George Schnitzer for writing the technical captions.

Special thanks to Smithsonian staff, including John R. Dailey, Joe Anderson, John Benton, Joanne Bast, John Anderson, Mark Avino, Dora Blair, Barb Brennan, Rebekah Brockway, Claire Brown, Ann Carper, Rick Cochran, Dorothy Cochrane, Martin Collins, Roger Connor, Tom Crouch, Doug Dammann, Christina DiMeglio-Lopez, Dik Daso, Von Hardesty, Tom Dietz, Heather Foster, Liz Garcia, Laura Gleason, Dan Goldstein, Peter Jakab, Jeremy Kinney, Roger Launius, Russ Lee, Cathy Lewis, Joanne London, Eric Long, Anne McAllister, Bob McLean, Beatrice Mowry, Matt Nazzaro, Valerie Neal, Allan Needell, Mike Neufeld, Bob Norton, Dave Paper, Laurenda Patterson, Chris Pratt, Patsy-Ann Rasmussen, Alex Spencer, Monecia Taylor, Bob van der Linden, Jeannie Whited, Scott Willey, Frank Winter, and Derrick Wright for assistance with administrative, collections, editing, and exhibition support.

To my photography and design interns Jennifer Keech, Emily Griffith, Lauren Wile, Rob Wooten, and Cheryl Zimbelman, I am grateful for your assistance.

To my friends Anna Potts, Reena Jehle, Lissa Stewart, T. T. Brumm, Catherine Myles, and family John Russo, Joan Russo, Kate Russo, Eva Russo-Eberhard, Aimee Russo, Angela Russo, and Mary Craddock, many thanks.

I especially want to thank Todd Schneider and John Westergren at Epson for the in-kind donation of beautiful exhibition prints, Marc Schotland at Bogen for the use of the Elinchrom Lights, Lin Ezell at the National Museum of the Marine Corps, and T.L.B. for his generous donation of the Hasselblad camera system used exclusively on this project.

And finally, thank you Mary and baby Jack for your "gestational magic."

Special thanks to Epson America, Inc., Bogen Imaging, National Museum of the Marine Corps, Smithsonian Affiliations, and the Smithsonian Women's Committee for their generous support.

Exhibition prints were made by Todd Schneider of Epson America, Inc. on Epson's UltraSmooth Fine Art Paper.

IN PLANE VIEW

\>\>

© 2007 powerHouse Cultural Entertainment, Inc.
Photographs © 2007 Carolyn Russo, Smithsonian Institution, National Air and Space Museum
Text © 2007 Patty Wagstaff
Text © 2007 Anne Collins Goodyear
Text © 2007 David Romanowski, Smithsonian Institution, National Air and Space Museum

Published in the United States by powerHouse Books,
a division of powerHouse Cultural Entertainment, Inc.
37 Main Street, Brooklyn, NY 11201-1021
telephone 212 604 9074, fax 212 366 5247
e-mail: inplaneview@powerHouseBooks.com
website: www.powerHouseBooks.com

First edition, 2007

Library of Congress Cataloging-in-Publication Data:

Russo, Carolyn.
 In plane view : abstractions of flight / photographs by Carolyn Russo ;
foreword by Patty Wagstaff ; introduction and essays by Anne Collins
Goodyear. -- 1st ed.
 p. cm.
 "Smithsonian National Air and Space Museum."
 ISBN 978-1-57687-405-9
 1. Photography, Artistic. 2. Airplanes--Pictorial works. 3. National Air
and Space Museum. I. Wagstaff, Patty. II. Goodyear, Anne Collins. III.
Title.
 TR655.R87 2007
 779'.938773--dc22
 2007060116

Hardcover ISBN 978-1-57687-405-9

Printed and bound by Midas Printing, Inc., China

Book design by Mine Suda

A complete catalog of powerHouse Books and Limited Editions is available upon
request; please call, write, or visit our website.

10 9 8 7 6 5 4 3 2 1

Printed and bound in China